the artist's
Watercolour
Problem Solver

Collins

the artist's Watercolour
Problem Solver

Practical Solutions to
Common Watercolour Problems

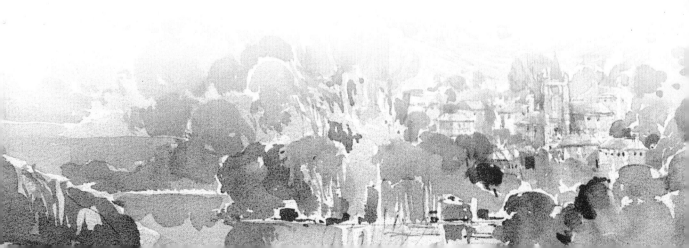

First published in 2003 by
Collins, an imprint of
HarperCollins*Publishers*
77-85 Fulham Palace Road
Hammersmith
London W6 8JB

The Collins website address is
www.collins.co.uk

Collins is a registered trademark of
HarperCollins Publishers Ltd

09	08	07	06	05	04	03
7	6	5	4	3	2	1

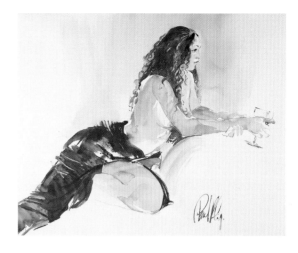

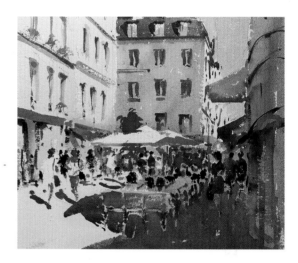

**A catalogue record for this book is available
from the British Library**

Editor: Geraldine Christy
Designer: Penny Dawes
Indexer: Susan Bosanko

The text and illustrations in this book were
previously published in *The Artist* magazine.

ISBN 0 00 714948 4

Colour reproduction by Colourscan, Singapore
Printed and bound by Bath Colourbooks

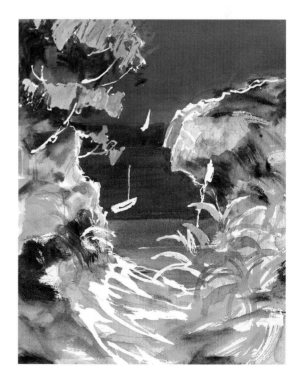

PICTURE CREDITS
TOP: *Vin Rouge*, Paul Riley
MIDDLE: *Parisian Side Street*, Gerald Green
BOTTOM: *Portuguese Creek*, Tom Robb

CONTENTS

INTRODUCTION

Following the worldwide success and popularity of *The Artist's Problem Solver*, first published in 2001 by HarperCollins from the long-running series in the UK's *The Artist* magazine, we decided to collaborate on this second publication, concentrating this time on the most helpful watercolour problem-solving articles from the magazine series.

As I mention in my introduction to the first book, the aim of the ongoing series on which this most recent book is based is to tackle painting enthusiasts' most common problems by posing their questions to top-class artist-tutors, who offer advice and possible solutions to each problem through down-to-earth instruction and demonstrations.

In this latest publication, the problems covered are those encountered specifically by watercolourists, although you may find that the ideas are relevant to painting subject matter

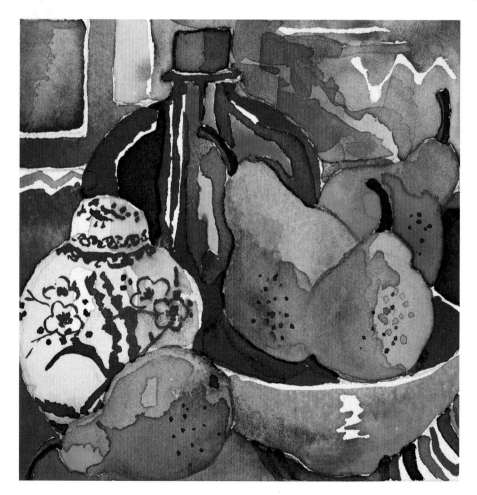

Pears in the Studio
(Anuk Naumann)
20.5 × 20.5 cm (8 × 8 in)

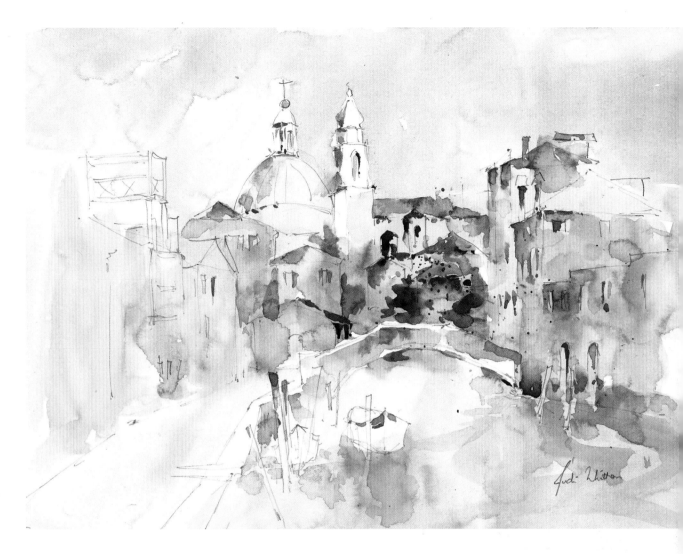

Venice (Judi Whitton)
25.5 × 33 cm (10 × 13 in)

in other media too. Watercolour is a wonderfully expressive medium, offering endless opportunities for portraying subjects, but it can be unpredictable and you may need guidance to overcome sticking points and reach your full potential. Here you will find a myriad of different watercolour problems which cover topics ranging from finding inspiration, using your chosen colours to their greatest effect and working up pictures from sketchbooks, to creating impact through tone control and recognizing the point at which to stop work on a painting. The subjects covered are also numerous and feature landscapes, seascapes, interiors and still-life paintings, as well as nudes, flowers and fabrics

amongst others. There is something of value to every painter, whatever their level of skill.

Each of the questions posed has been tackled by well-known practising artist-tutors with empathy for students' concerns and needs. These include John Lidzey, Paul Riley, Ray Balkwill, Tom Robb and Judi Whitton, who offer advice based on their own approach to the subject or problem in hand. The result is a cornucopia of information, advice and inspiration to encourage watercolour painters of all levels of experience.

Sally Bulgin

Publishing Editor, *The Artist*

1 A MATTER OF SUBJECT

What shall I paint next? Can you suggest new subjects that will stimulate renewed inspiration?

Answered by:
John Lidzey

The problem of finding a subject to paint seems to affect many artists, while others appear to have no trouble at all. From my own early experience I know the frustration of wasting a morning in failing to find something worthwhile to paint. It might be seen, I suppose, as a condition that is similar to writer's block.

LANDSCAPES

For those within reach of a park or the countryside a landscape is always a stimulating subject. But one problem that occurs with many landscapes, especially those painted in watercolour, is that the results can look unexciting. Quite a few that can be seen in local exhibitions are views painted at

Houses by the Mere at Diss
15 × 47 cm (6 × 18½ in)

Houses in trees can make a very good subject. A sketch like this can provide a satisfactory reference for a finished painting. When the weather became wet I completed the view from my car.

midday (or thereabouts) in mild sunny weather. In many cases the scenery lacks any real interest, often being just a panorama of trees and fields.

There are more interesting possibilities to be found in landscape subjects related to twenty-first-century agriculture. The technology of farming is changing. Heavy machinery of all sorts now does the work of many people. Although lacking the rustic charm of nineteenth-century farm equipment modern farming machinery offers challenging painting subjects.

For those who have no interest in the current farming scene, yet wish to produce interesting landscapes, there is always inspiration to be gained from making the weather a dominant feature. Working just from sketches made on the spot, it is possible to create paintings in the studio with an appearance of rain and wind. Some excellent techniques for depicting these effects are shown in Patricia Seligman's book *Weather – How to See It, How to Paint It* (unfortunately out of print, though your local library may have a copy). You may also find Turner's landscape work to be useful in this

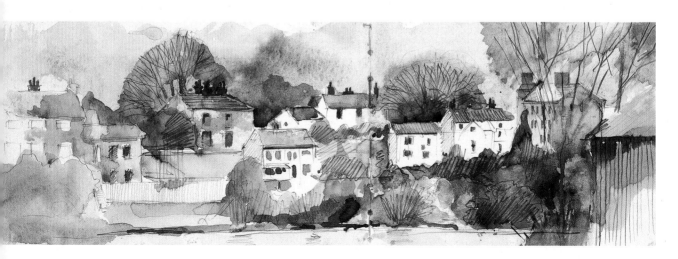

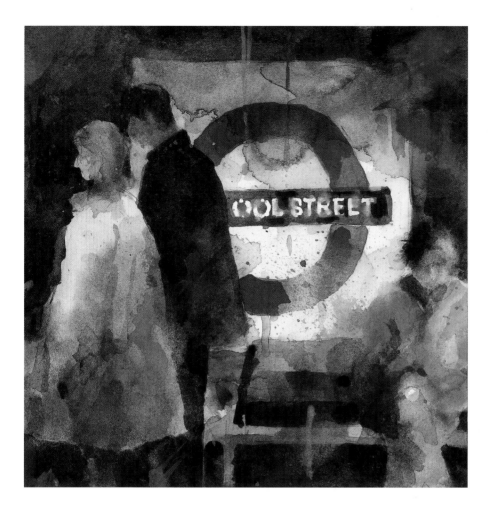

**Liverpool Street
Underground**
18 × 17 cm (7 × 6½ in)

*Inspiration can even be
found below ground. I kept
this painting very loose,
allowing the paint to run
freely, dropping pure
colour into wet washes; I
further broke up the
imagery by flicking colour
onto the painting surface.*

context. Try to see some of his watercolour
paintings and sketches in Tate Britain at Millbank,
London, or at least in reproduction in the many
books on his art.

STREET SCENES

There is also great potential in urban scenes. A
good way of working in cities is to make sketches
and to take photographs. These can often make
excellent references for finished paintings that can
be produced in the studio or at home. Many years
ago, when I lived in London, I spent many early
mornings sketching in local streets from the
comfort of my car, afterwards taking a
photograph of the same subject to correct any
infidelities of scale or perspective in my sketch.

While you are in the city with a camera see if
you can use it in some of the less public spaces.
Open-air cafés can make splendid subjects. Buses,
trains and railway stations can be good to paint,
too. Many cities have a river running through –

look at the possibility of photographing and
sketching from a bridge. Beautiful effects can be
obtained with the sun reflecting off the surface of
the water. Additionally, you could try using your
camera at dusk in the city – you can capture
some really magical urban scenes in the half-light.
There can be a wonderful air of melancholy
encapsulated in a lighted window with the
curtains drawn just as dusk begins.

INTERIORS

Subjects taken from towns and cities can make
expressive pictures. These are public and
impersonal, but domestic settings can show
intimate moments that are intriguing. I cannot
pass the lighted window of a house without just
the shortest peek inside. Interiors are like stage
sets waiting for the play to begin and a painting of
an interior can have the same theatrical quality.
Kitchens, bedrooms, bathrooms, hallways and
sitting rooms can offer interesting subjects.

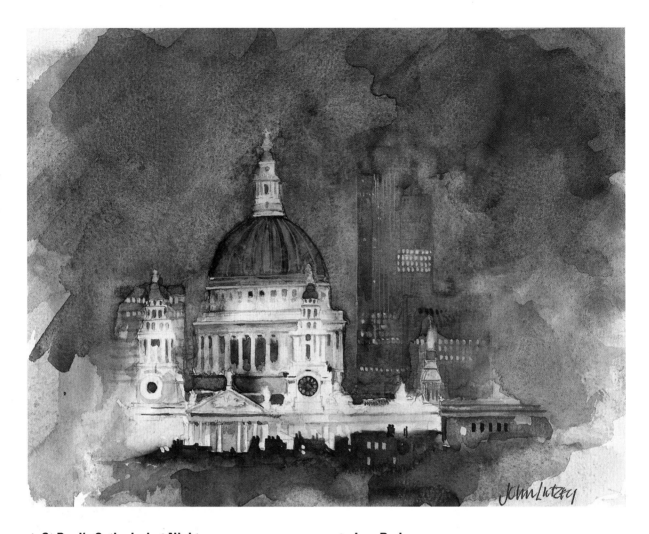

▲ St Paul's Cathedral at Night
35.5 × 40.5 cm (14 × 16 in)

Cities at night offer interesting subjects. It is best to work from a photograph rather than try to create anything on the spot. In this case I introduced silhouettes of houses in the foreground to reinforce the floodlit effect. Loose brushwork was used for the sky to give it interest.

▶ In a Bedroom
51 × 30 cm (20 × 13 in)

A figure sitting against a window makes an excellent subject. A semi-silhouette like this can be easier to work on than a figure illuminated from the front or side. Here I used limited colours: mainly Yellow Ochre, French Ultramarine and Indigo. For the highlights I used white gouache.

If you have not tried painting an interior before do not be too ambitious at first. Begin with the simplest of subjects; perhaps a chair against a plain wall. Maybe an item of clothing could be draped over the back. A picture of some sort could be positioned on the wall behind the chair. A simple theme such as this can be very worthwhile. The light and shade from a nearby window can create interesting patterns on the wall. Such a subject can help develop your observational skills and your drawing ability. If you find the drawing a real

problem you could take a photograph and work from that, but only use the photograph for drawing reference. When it comes to the painting stage rely on what you see in the subject, not what is in the photograph.

Windows painted from the inside looking out can make good subjects. A table placed close to the window with such articles as a plant, flowers, jug, vase or bowl of fruit could work very well. If the window has a sunny aspect this could be an added bonus. Remember, however, that patterns

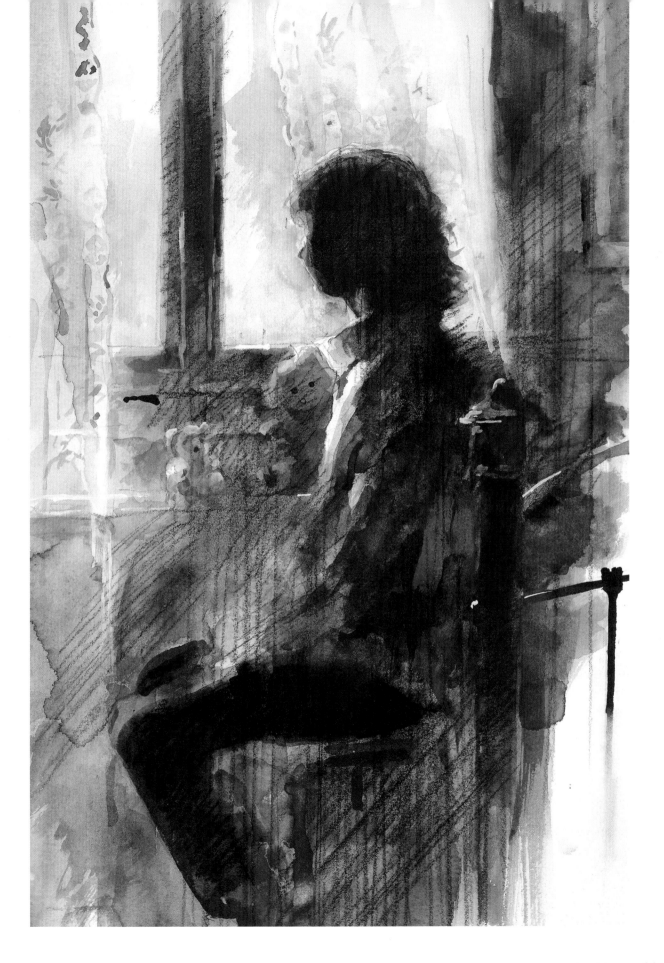

of light and shade change very quickly. The sunlight can be totally different within an hour or less. If you are quick enough you could make a quick pencil sketch that identifies the light and shade at a particular point in time. Alternatively, take a photograph!

Doors and doorways always make fascinating subjects. A view through a half-open door can be an intriguing possibility. The viewer of the painting is left in suspense about the part of the room that cannot be seen. Experiment with this kind of subject. Position yourself in relation to a half-open door so that something interesting is in view, possibly a figure looking out of a window. If the view is into a bedroom maybe some discarded clothing might be seen or even just hinted at. Other possibilities might be an open cupboard door revealing the contents, an untidy chest of drawers with items spilling out, a table set for a meal or part of a dresser with chinaware. These are eminently paintable subjects, which in many cases are not too difficult to draw (with a little practice). The joy of such simple subjects is that they are readily available and unlike outside ones the state of the weather is not a consideration.

Bonnard and Vuillard devoted most of their lives to interiors, producing work that enthrals and fascinates the public and critics alike.

THE STILL LIFE

Still life has been popular with artists since the sixteenth century. Early examples of the form were laden with symbolism, chiefly to remind the spectator of the transience and uncertainty of life. Thus an arrangement might consist of butterflies, skulls, mirrors, candles, hourglasses and similar objects that hint at the temporal nature of human existence. Even now we are subject to an unpredictable course of events, so perhaps there is still room for such items gathered together to form the subject for a meaningful still life.

Antique shops are an obvious place to start looking for appropriate and interesting objects, although these are often expensive. Charity shops and car boot sales are alternative sources of unusual items, going cheap. It is surprising how battered, rusty items can make good subjects for a still life, especially if placed in conjunction with something delicate and fresh. Imagine, for example, a composition created from a broken framed mirror and a few flowers, especially with the right kind of lighting. An anglepoise lamp, its light directed from an oblique angle, could provide dramatic lighting for a really interesting painting laden with 'symbolic' meaning.

Allow yourself to be influenced by the late still lifes of Cézanne, whose simple arrangements of everyday objects were the basis of a series of

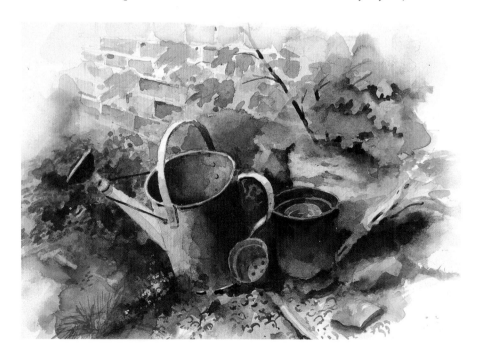

Gardener's World
23 × 30.5 cm (9 × 12 in)

A few items in a garden corner can be all that are needed to make an interesting subject. I have positioned the watering can and a flower pot at odd angles to suggest an untidy effect. The weeds and stones contribute to a feeling of neglect that is slightly at odds with the title of the picture.

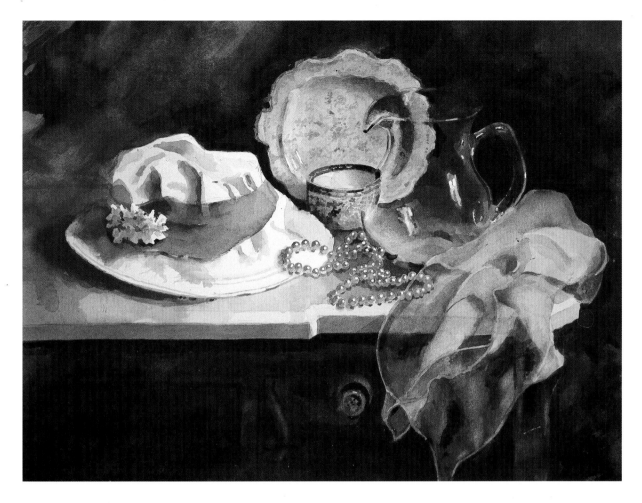

Still Life with Glass Jug
42 × 56 cm (16½ × 22 in)

Just a few objects of varying colour, shape and texture can be stimulating to paint. I carefully drew and painted this set-up to provide a 'realistic' quality, but a much looser treatment can also make for an interesting painting. Keep your eyes open in antique shops for items that have particular qualities.

inspirational paintings. A plate, a glass and some apples can be all that is needed. If you are uncertain about handling complicated subjects, a simple arrangement of no more than three or four pieces of fruit is all you need.

Think about a still life based on a particular theme – a kitchen-based subject, for example. Such simple items as a saucepan together with some vegetables imaginatively grouped together and suitably lit, could make a wonderful subject for a watercolour painting.

Kitchen equipment has lots of potential for still lifes. Choose from scales, mixers, sieves, bowls, knives, graters, whisks and similar items, plus the items of produce and foodstuffs that may be found in most kitchens. Broken crockery in the kitchen offers a marvellous subject for a still life. For example, a teapot, a sugar basin, a saucer, a broken cup and some spilt tea could make an intriguing painting.

MANY POSSIBILITIES
Think about your subject matter well in advance of starting work. Do not just stretch a sheet of paper and then wonder how to fill the space. Always be on the lookout for suitable subjects and keep notes about your ideas.

You might see a painting in a gallery that could spark off an idea of your own, or two objects in conjunction with one another. Good subjects do not just present themselves – they have to be thought about and created through observation.

2 FRESH START

I don't like this painting – it's so tired and lifeless.
Can you help?

Answered by:
John Mitchell

The first thing to appreciate is that, at times, everyone has this problem. Let us look at how you can give yourself the best chance of producing fresh and exciting works.

Choice of subject matter is important. Go for something original, not secondhand. Go for something exciting, not dull. Go for something you know about, something that arouses your curiosity, that 'turns you on'. Fine words, but how do you do it? The answer is to explore the world around you in your sketchbook.

I cannot emphasize the benefits of using a sketchbook enough. Forget about copying other people's paintings or photographs. Forget about that lovely calendar, or the postcard from a friend. Find your own subject matter. Here is a list to think about: family and friends, gardens, parks and holiday resorts, harbours and docks, beaches

and woods, plant and mechanical forms. You could use a favourite poem or an excerpt from a book, even a piece of music. Visit exhibitions and look at art books to find inspiration.

PRE-PLAN YOUR PAINTING
Launching right into a painting from a sketch without doing some pre-planning is a mistake. You may find, too late, that one object should not

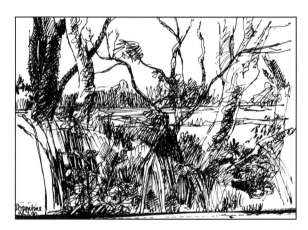

I developed thumbnail composition sketches from a previous pencil sketch.

▲ *These two sketchbook studies were made in fine felt-tip pen in an A6 sketchbook. It is essential to collect source material in this way. As you finish each book, file it away safely. It will provide material for years to come.*

3 START TO FINISH

Answered by:
Judi Whitton

Why do I have problems working up a satisfactory finished picture from an exciting sketchbook study?

Racing home, we rounded the bend. Suddenly, before us was the most lovely subject for a painting. We quickly parked. Time was limited, so out with the sketchbook, and I made a hasty study in pencil with just the essential details – a little tonal shading and a few colour notes. I took a photograph and jumped back in the car and we carried on with our journey.

Winter Scene
15 × 20.5 cm (6 × 8 in)

It was a dull, rainy day. I sketched from the car and there was little tonal contrast. It all seemed very unpromising but my sketch (right) became a challenge. I tried to compensate for the narrow tonal range and emphasized any local colour. Above all, I stopped while the painting still had the 'sketchbook feeling'.

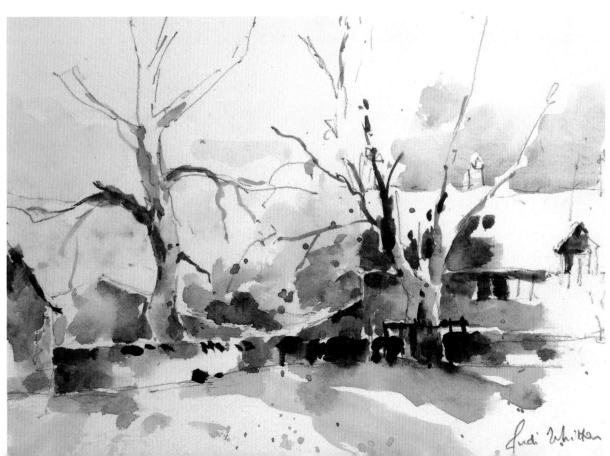

FROM SKETCH TO PAINTING

Some time later, back in the studio, I used my sketch as a reference to complete a successful watercolour painting that exactly portrayed my impression of what I had seen.

Or did I? In fact, it is most unlikely! In the ideal world this is what is expected; after all, Turner produced some stunning watercolour paintings based on little spidery sketches. He travelled on horseback without the company of a state-of-the-art camera. So why is it so difficult? What is the missing link?

This is the dilemma. How often have I heard a fellow artist say that they were pleased with their sketch, but disappointed with the finished painting. I have had many long and intriguing discussions about the problems that arise when working up a successful painting from a promising sketch. These problems can occur either in the studio after the sketch has been made, or outside when a sketch has been used as a preliminary to the painting.

I do not believe that the basic problem lies in how the sketch itself is made. Whether it is a thumbnail sketch, a detailed line drawing, a tonal study or even a little painting, there seem to be many pitfalls before the final painting is produced. The problem seems to lie in how the sketch is used to produce the painting.

WHICH SKETCHES SHOULD I USE?

The first question to ask yourself is whether the subject is right for a finished painting. Some people might think that a particular subject is ideal for a sketchbook study but there is not enough 'weight' in it for a finished painting. The magical thing about being an artist is that there are no rules. The illustrations on page 19 show the sketch and final painting of a winter scene. I framed it like this because I felt I had finished it, even though there was not a great deal of content. I did not really have any more to say and hoped I had caught the essence of the subject. But what was most important was that this picture still had the 'sketchbook feeling' about it.

HOW TO KEEP THE 'SKETCHBOOK FEELING'

Is the 'sketchbook feeling' the missing link? What is it about an artist's sketchbook that we all love? I have often watched artists demonstrate at our local art society. Usually they bring along a few of their finished framed pictures and then generously pass round their sketchbooks while doing the demonstration. Somehow, the sketchbooks never get very far round the room because someone in the audience becomes totally absorbed in it.

Why is it that the sketchbook is so fascinating? So often it is full of life and vigour and a sense of

Hidden Treasure

32 × 48 cm (12½ × 19 in)

What an irresistible subject! But I was careful in the way I painted it. The sketchbook enabled me to choose the angle I liked. As in Winter Scene, *the light was so poor that a photograph was impossible, and my sketches were invaluable.*

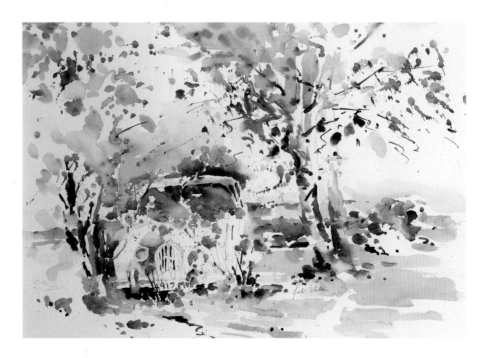

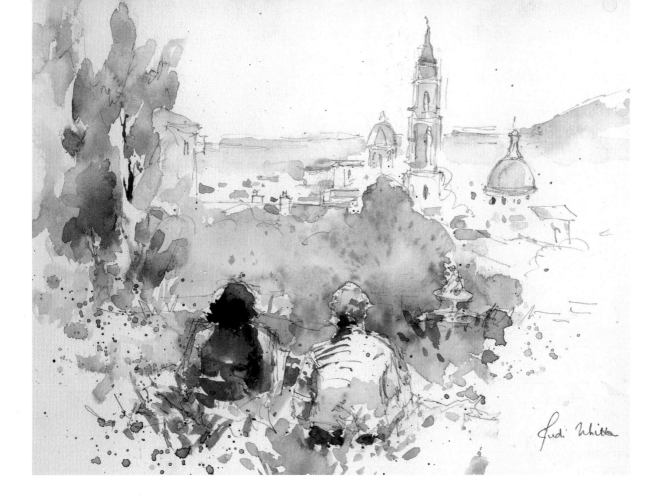

Sarah and Barbara Painting Florence
24 × 29 cm (9½ × 11½ in)

I had intended to depict the wonderful panorama of Florence. But who could resist concentrating on my friends, settled in the grass? I realized from my sketch that I needed to change the emphasis of the painting.

spontaneity, which is sometimes lacking in the framed work. Also it is a 'private' thing. A sketchbook is for the artist's use. Generally it is not intended for public scrutiny, so there is a personal feeling about it. It is these qualities of spontaneity and 'personal' experience that you should strive to hold onto in the finished work.

CHOOSING THE SIZE OF THE FINISHED PAINTING

Having decided that you would like to use your sketch as the basis for a watercolour painting you then need to decide what size of paper would be best. If the sketch sits comfortably on the page it is probably useful to use a piece of paper for the finished work that is of the same proportions as the pages of the sketchbook. This seems obvious, but it does help!

As regards the size of paper, as ever, there are no rules. I suggest that you envisage the final picture and imagine what would look best. A detailed sketch of a busy street scene can look charming as a small picture, whereas a simple expansive beach subject might be perfect on a grand scale where the brushstrokes can be bold.

USING THE SKETCHBOOK

I came across the subject for the painting *Hidden Treasure* (opposite) a few miles from home. An old Jaguar car was well hidden in the foliage. I was a bit worried that the subject was rather whimsical and I was most anxious not to make it too pretty or 'greetings cardish'. Although the light was poor and it was a little boggy underfoot I hoped that I would have time to do the painting on site.

I made a few sketches of the car and trees from different viewpoints. On this occasion I was using the sketchbook to investigate different compositions rather than with the intention of preparing a subject to work into a finished painting in the studio. The sketches would also be useful if interrupted during my painting.

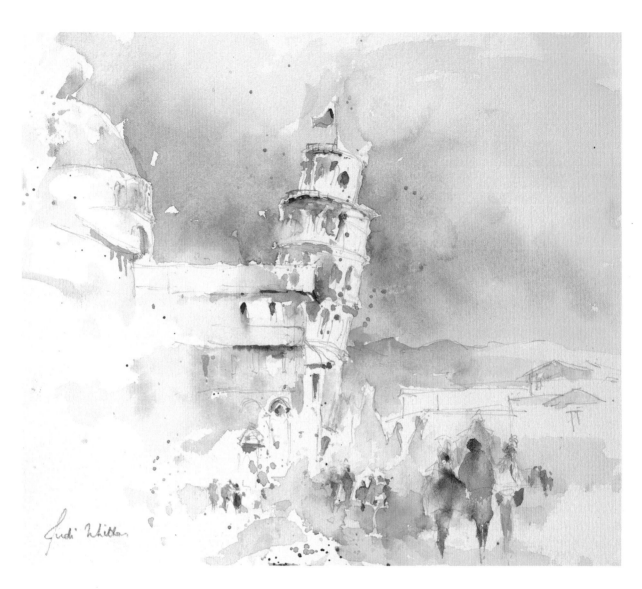

Pisa

21.5 × 26 cm (8½ × 10¼ in)

I tried to keep 'fresh eyes' as I looked at this familiar place. The sketch needed to be accurate and it helped to incorporate the movement of people into the composition.

By walking around the car and sketching I was both studying the subject and thinking about how to paint it. (I took a photograph, too, but when I looked at it later it was totally useless as the car was completely hidden in the shadows.) I was most anxious to convey the impression that the trees and car had become 'one' and to keep a lively feel to the foliage. I tried hard not to overwork the painting, and this is where sketches can help to form your ideas at the beginning.

In *Sarah and Barbara Painting Florence* on page 21 my sketchbook was invaluable. I was painting in Italy with my friends. After problems with onlookers I had tucked myself away in a quiet spot. We were in the Boboli Gardens overlooking Florence and the weather was showery. My friends settled down on the grass. They were much farther apart than shown in the painting and I used the sketchbook to bring them closer together and to position them sympathetically with the panorama in front of us. I had originally intended to concentrate on the wonderful view of Florence, but I could soon see from my sketch that my friends were the most important part of the painting! In addition to this the sketch also became my insurance policy in case my friends moved position, or the threatening rains arrived.

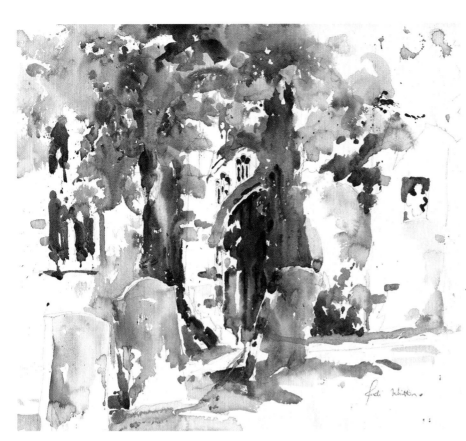

Churchyard, Stow on the Wold

38 × 43 cm (15 × 17 in)

This was painted on the spot with no preliminary sketch. I wonder if it would have gained or lost had I done one?

ACCURACY AND MOVING SUBJECTS

The leaning tower of *Pisa* (opposite) is so well known that it is difficult to keep the spirit of the place and to paint it as if you are looking at it for the first time. Also I had to 'edit' extensive 'rescue' works around the base of the building. It was hard not to exaggerate the 'lean' on the tower. In this case the sketch needed to be accurate as well as conveying the beauty of this exquisite structure. It was interesting to observe that the flagpole on top of the tower was vertical. Here the sketchbook was useful, too, to record the people and incorporate them into the study, rather than make them look as if they were an afterthought.

DO I NEED A SKETCH?

The painting of the *Churchyard, Stow on the Wold* (above) is included here even though I decided to make no preliminary sketch for it. I looked at the subject for some time and made decisions, and then just painted it. Sometimes I prefer not to give any concentration to the sketch and save all my resources for the painting. Bearing in mind the expression 'analysis leads to paralysis', I worry sometimes about the slight risk of over-preparing for a painting and going a bit stale, especially as watercolours often benefit from a feeling of spontaneity. But there is no substitute for doing a lot of thinking before and during the painting.

OVERALL VIEW

From these experiences I have tried to learn the best way of interpreting sketchbook studies. The major problems have arisen when my sketch looked very acceptable and I have simply used it to complete the finished work without ever establishing what the sketch was really about. Somehow, these pictures lack vitality. Although considerations such as composition, tonal balance and colour relationships are important in all work, it is the feeling that the painting evokes that makes it special.

To summarise: there are no rules. If you like your sketch, think about what it is that you like most. Extract the essence, and keep that idea uppermost in your mind as you tackle the painting. When you feel you have 'said it', it is time to stop.

4 ENHANCE YOUR COLOURS

Answered by:
Paul Riley

How can I use colour to give vitality to a subject and make it appear almost more real than it is?

When painting it is natural to regard colour as like for like. By this I mean that we tend to see the view before us as a kind of photograph where the colour is local, sometimes given vibrancy by the sun. However, when it is painted as such the result often looks disappointing, drab and dull, rather like an instant photograph. The reason for this is that the colour is not exaggerated enough.

HEIGHTENING COLOUR
It helps to remind yourself that you are compressing nature into a smaller format. The vast landscape, for example, is to be reduced and distilled to fit onto a piece of paper or canvas in such a way as to indicate the intensity of the sun's effect on foliage, water, flowers or flesh.

This approach applies, I believe, to all media on all surfaces. Thus, when thinking about how to represent a blank white wall it is necessary to see

Autumn Tree 1
29 × 39 cm (11½ × 15¼ in)

This was painted in primaries and secondaries using only the six colours described in the text. They were applied in various ways from stripes to dots and merging soft edges.

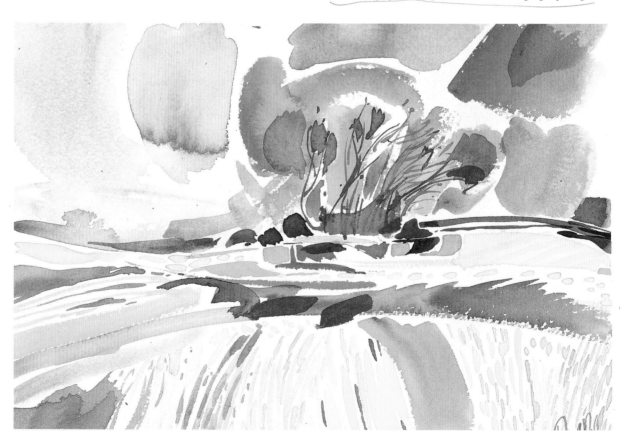

all the subtle nuances of colours that are present in it in order to make it appear real.

For example, the blue of daylight from an adjacent window will merge into violet where the white of the wall picks up the red-orange electric light. This, in turn, can cause yellow casts, which can then be tinted again by light bouncing from the floor covering, whatever that may be. All this is apart from any surface blemishes on the wall that can add further colour variations.

When seeing these variations a painter needs to heighten them to make the subject appear almost more real than it is. The same, for example, applies to shadows that are not necessarily the grey drab areas that they seem. Look deeply and you will see that they reveal colours more vibrant than their illuminated counterparts.

Autumn Tree 2
29 × 39 cm (11½ × 15¼ in)

I repainted Autumn Tree 1 using the complementary colours. This resulted in some exciting surprises – blue tree, orange sky, red fields!

COLOUR MECHANICS

To understand how to apply colour you need to know how it works. In transparent media like watercolour, inks and transparent acrylics there are two issues to consider: chromatics, and pigment behaviour. In opaque media pigment behaviour is not critical. Chromatics affects all media, and may be divided into hue and tone. Hue refers to the colour of something, tone to the lightness or darkness, within a particular hue. A hue – primary, secondary or tertiary – is specific.

Let us look at the primary colours. The first point to note is that the colour manufacturer cannot make an absolute primary. Red, for example, will invariably be tainted by the other two primaries: blue and yellow. Yellow and blue are also similarly affected – yellow by red and blue; blue by red and yellow.

Understanding this radically affects secondary colour mixing. Examples of these primary types are as follows:

1) yellow red = Cadium Red
 blue red = Permanent Rose
 (quinacridone)

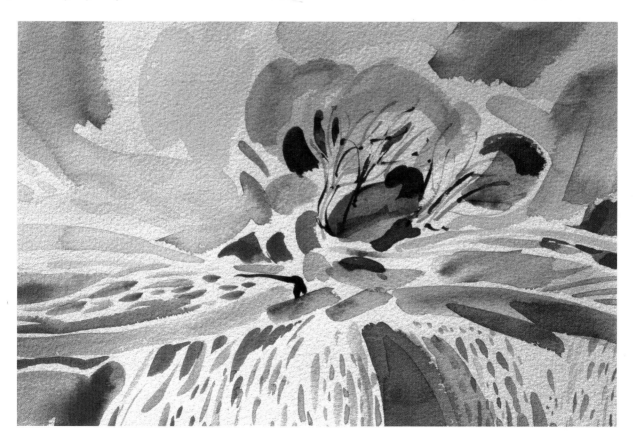

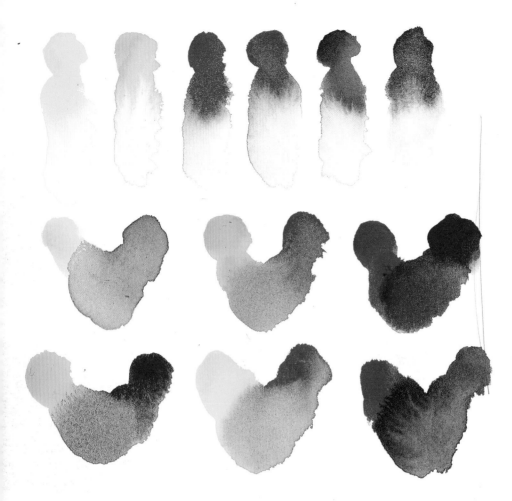

Primaries
(left to right): Lemon Yellow (yellow and blue); Cadmium Yellow (yellow and red); Permanent Rose (red and blue); Cadmium Red (red and yellow); Phthalo Blue (blue and yellow); French Ultramarine (blue and red).

True secondaries
(left to right): Lemon Yellow and Phthalo Blue; Cadmium Yellow and Cadmium Red; Permanent Rose and French Ultramarine.

Tertiary secondaries
(left to right): Cadmium Yellow and French Ultramarine; Lemon Yellow and Permanent Rose; Cadmium Red and Phthalo Blue.

2) red yellow = Cadmium Yellow
 blue yellow = Lemon Yellow
3) red blue = French Ultramarine
 yellow blue = Phthalo Blue

Therefore to mix true secondaries from these primaries you should use the following colours:
1) Green: mix a blue yellow – Lemon Yellow – and a yellow blue – Phthalo Blue.
2) Orange: mix a yellow red – Cadmium Red – and a red yellow – Cadmium Yellow.
3) Violet: mix a red blue – French Ultramarine and a blue red – Permanent Rose.

Any other mixes from these colours will produce a tertiary colour, which is perfectly acceptable but must be understood as such. For example, mixing Cadmium Yellow with French Ultramarine is the equivalent of mixing yellow, blue and a proportion of red. Producing tertiaries like this is a way of neutralizing a colour.

Tertiaries break down into three groups: red biased (more red than yellow or blue), which are termed browns; yellow biased, which are beiges; and blue biased, which are greys.

COMPLEMENTARY COLOURS

So far I have talked about hues in isolation. However, when they are put adjacent to one another various things occur that affect the eye, which, in transmitting the information, can excite the brain. The complementary colours of red and green, blue and orange, yellow and violet, when seen in close conjunction, excite the brain because although the eye sees two colours – for example red and green – it is, in fact, aware of three: red, yellow and blue.

The artist can use these conjunctions to draw the viewer's eye to specific parts of a painting or to enhance a particular colour. When the principle is applied to neutral colours you are able to pull forward primaries or secondaries in painting.

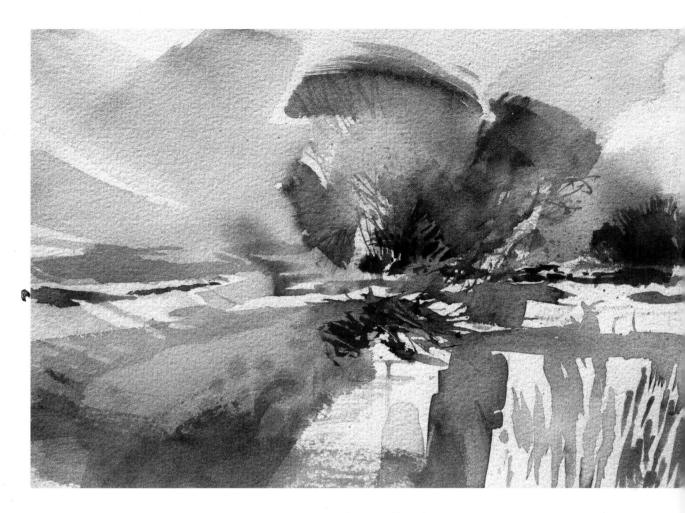

For example, a red will come forward in a painting if the colour surrounding it is a green grey.

COLOUR SCHEMING

In order to stimulate a way of seeing a subject you need a scheme or method to counteract the obvious. One way I do this is to break down the colour zones in front of me into primaries and secondaries in their various tones, cutting out all tertiaries. So, for example, greys will be either blue or violet; browns, red or orange; beiges will become yellow or orange. I then produce a colour sketch based on this to see how powerful the effect will be.

Subsequently I will produce another study where I will replace all the colours with their complementaries: so greens will become red; violets will become yellow; and oranges will become blue; and so on. This will produce quite startling combinations with red trees, orange skies and yellow shadows!

Autumn Tree 3
29 × 39 cm (11½ × 15¼ in)

Finally, I painted the subject using all neutral colours: browns, greys, beiges, which were mixed using the primaries. The near blacks, for example, were obtained by mixing French Ultramarine with Phthalo Blue.

To complete the process I then produce a sketch that employs the best of both worlds. I find that the colour choice is purely subjective and can have many variations. In a painting where boldness is the criterion this method helps to release inhibitions about local colour and enables the painter to adapt colour to his or her choice.

VIBRANT NEUTRALS

On the basis of the previous exercise I like to look at how I can make my neutrals sing to a similar tune. The way to do that is to think carefully about their mixture. Greys can vary from blue to

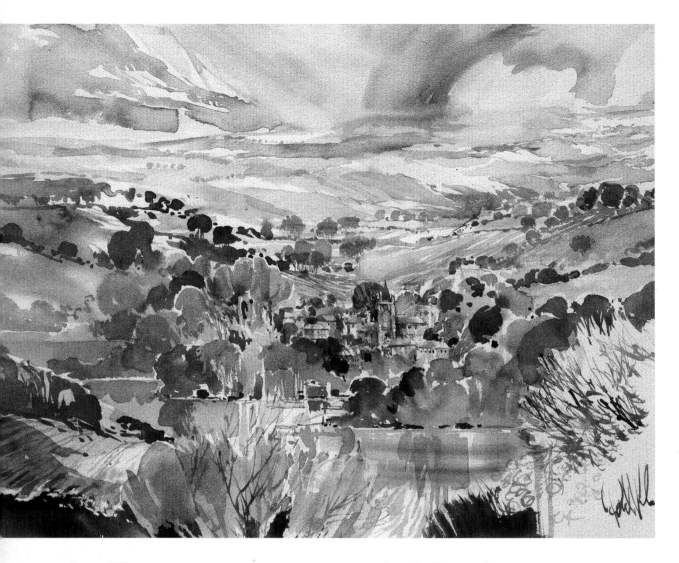

▲ Devon Village
57 × 76 cm (22½ × 30 in)

When painting a vista like this the likelihood is that the whole picture could look oppressively green. To counteract this you need to search for every other colour possible, hence the violet, blue and gold trees, and yellow fields, with blue and mauve skies. All the neutral colours have been enhanced by making them positively complementary to their adjoining colours.

▶ Coombe Courtyard
57 × 76 cm (22½ × 30 in)

The strength of colour in the painting is due to the preponderance of primary and secondary colours, which have been used unadulterated by mixing on the paper rather than in a palette. One other way of ensuring the clarity of the colour is to employ the white line technique to ensure that passages of colour do not overlap and thereby cause unnecessary tertiary mergings.

green to violet, and depending on which colours they are to complement will vary accordingly. Green grey to red, violet grey to yellow, blue grey to orange are some of the options.

Browns do not have to be 'mud' if seen in this context. By varying the amount of red, yellow or blue, to complement the colour it is adjacent to,

you can enhance the quality of your browns an immeasurable amount.

When mixing any of these colours it is as well to bear in mind that the increments to change the colour may be very small, so colour testing on an adjacent piece of paper will help to avoid disappointment. Be brave, be bold!

▶ Plums and Roses

47 × 57 cm (18½ × 22½ in)

I tried to obtain the strength of colour in this painting by contrasting the deep-toned primaries with pale secondaries and even paler neutrals. The greys were all mixed to complement the vibrancy of the yellows, so where the yellows tended towards orange the greys were bluer, but where the yellows were more green the greys had more red in them. This is not a hard and fast rule, but it pays to think about it.

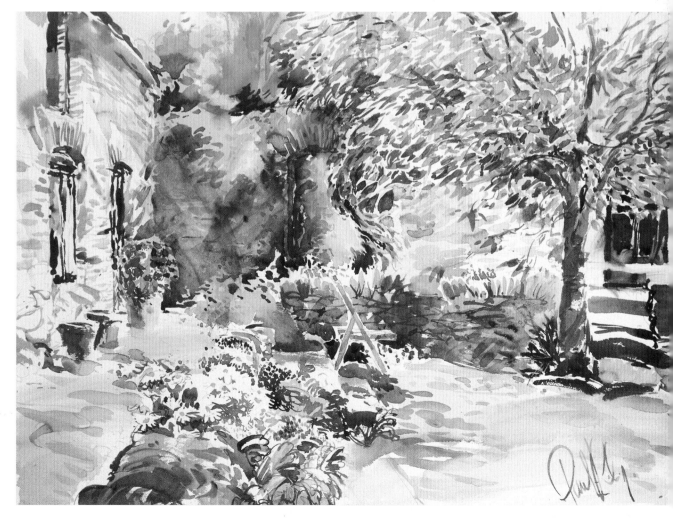

5 TIDE LINES

How do I make my boat and harbour scenes look more convincing?

Answered by:

Ray Balkwill

For many artists there is nothing more inspiring than sketching or painting in a bustling harbour. It is also one of my favourite subjects to paint. So why do many painters find the subject so difficult?

Perhaps it is because harbours hold so much subject material in such a confined space. A jumble of buildings, boats, people, mud, water, and much more, is a lot to take in and can be confusing at first sight. Another problem is the tide; the whole scene can change completely in a matter of minutes. Many students seem to find drawing boats difficult, too, and the thought of

groups of tourists peering over their shoulder can be a daunting one – particularly if they have never drawn a boat before. 'I can't draw boats' is something I frequently hear on my courses.

Quayside, Looe
26.5 × 36.5 cm (10½ × 14½ in)

Here I particularly liked the contrast of sand, still reflections and moving water, with the tide on the turn. I added some of the highlights using white gouache. Remember, light boats reflect darker and vice versa.

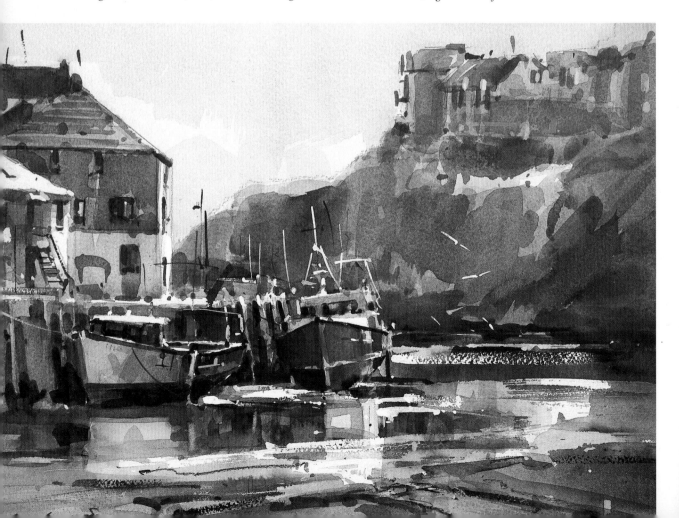

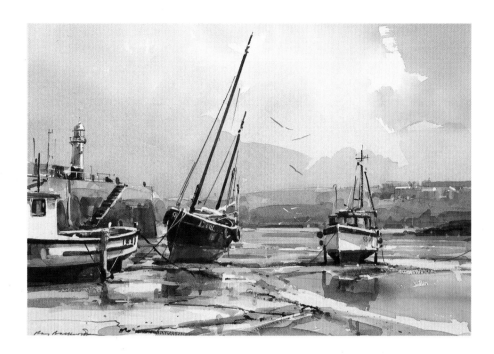

Low Tide, St Ives

26.5 × 36.5 cm
(10½ × 14½ in)

This painting of the harbour at St Ives, Cornwall, was done from a sketch and photograph. St Ives is all about light, so here the sky in the painting plays a big part. The verticals — the lighthouse and masts on the boats — are also important as they link the sky to the landscape.

The reasons are numerous, but many students have never even tried to draw boats. Many feel nervous because they know nothing about them. However, drawing and painting boats well does not mean that you have to fully understand their construction, though it helps if you have a little knowledge, or certainly an interest in the subject.

DRAWING BOATS

We tend to draw what we know from experience, rather than what we see with our eyes. Therefore, observing both objectively and analytically is something you must learn to do if you wish to improve your marine scenes. More often than not, boats are the focal point of a painting; it is important they are accurately portrayed, or at least look seaworthy. That does not necessarily mean adding more detail. What you leave out is often more important than what you put in.

The materials you choose for sketching will depend on your own preferences. Mine consist of an A3 cartridge pad, black felt-tip pens, charcoal and Conté crayon. I also use a smaller A4 landscape sketchbook for watercolour as well as tinted pastel paper (stretched) for watercolour and gouache.

There are no short cuts to drawing boats; it is a case of measuring and checking relative heights and widths and making constant comparisons of proportions. I find boats more interesting when

they are viewed in three dimensions; that is, where the viewpoint is such that the length, width and depth of the boat can all be seen. However, I often like the simpler, two-dimensional view, which may be the boat side-on, or perhaps looking from the bow or stern.

Boats can be a real problem if the tide is in and they are moving about in the water. But do not let that put you off; just decide on the best position of the boat, be patient and work quickly. Remember, though, the chances are that it could be taken out on a fishing trip at any time!

Many of my paintings are done at low tide. This is for a number of reasons, the most obvious being that the boats do not move around. But I also find that the whole structure is visually far more interesting. When they are tilted on the mud, as in *Low Tide, St Ives,* their masts create further compositional interest. I also find that low tide can create far more interesting shapes and contrasts than high water. Tidepools, seaweed, ropes and rusting chains can be exciting elements in a painting, of which *Polperro Harbour* on page 34 is a good example.

Making boats 'sit' on the mud, or float on the water is another common problem. Many students do not make the shadows, or reflections, quite dark enough, so that boats 'float' in mid air. With watercolour I often merge a wet-into-wet

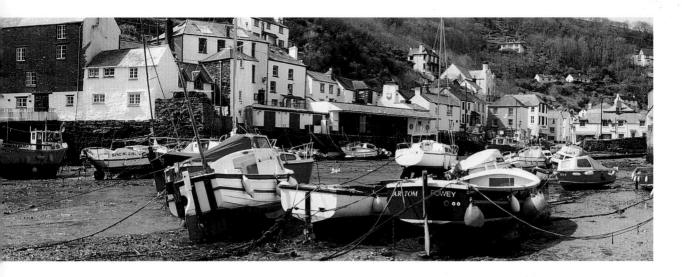

Photograph of Polperro Harbour

wash of the keel into the sand or water, making it difficult to distinguish between the two.

Choosing your viewpoint and your eye level is very important. You will find boats viewed from the quayside, where you have to look down on them, quite difficult as you will have to consider perspective and foreshortening.

COMPOSITION

Let us imagine you are on one of my painting courses and we go together to the picturesque harbour of Polperro, in Cornwall. Take a look at the photo above. This complicated harbour scene is typical, and shows the many problems you could be faced with. It is rare to find a perfect ready-made scene – you have to create one for yourself. There are many options and permutations in every scene and, in fact, you will never exhaust the endless possibilities.

To see what I mean, have a look at the examples on page 33, where I have arranged the elements in each picture in order to make a composition that works, based on the view above. Most marine subjects are painted in a landscape format, because this creates a sense of openness. But do not necessarily go for the obvious. You may find that a portrait, a square, or even a long narrow format is more challenging and works much better. To simplify the scene, I used three boats in each of the examples.

Do not be too ambitious; look for something that 'excites' you. Start with something simple – an interesting boat, the play of light on the quay, the reflections in a tidepool. Like the photograph, our eyes take in this broader view, full of buildings, boats and lots of detail. You may find working from photographs difficult as they record everything – it is the inspiration that you will need. This view in the picture above is made more difficult because the sun is behind us and everything is accentuated. This is why artists like to paint 'contre jour', against the light. Not only does it simplify the scene, but it also makes for a more dramatic subject.

When you are painting *in situ*, be sure to find out the state of the tide and remember that time is of the essence. If you have difficulty in seeing a composition, a simple viewfinder will help isolate the essentials. It is worth spending a few minutes doing a number of thumbnail pencil sketches to confirm your view. Think about and see solid masses, screw up your eyes and see the scene as shapes. Forget that they are boats or buildings at this stage.

The scale you work to is another important consideration. I suggest you start by working smaller rather than larger. I generally use a quarter sheet Imperial paper, but use a half sheet for mixed media – a full sheet measures 56 x 76 cm (22 x 30 in). However, boats are seldom in the right place, so you have to move them in or out of your picture. Do not be afraid to crop them; I often use a stern or bow of a boat to one side in

order to frame or help lead the viewer into the picture. Showing part of a boat in this way creates a sense of movement and intrigue, and hints at more beyond the confines of the picture. Degas (1834–1917) found that cropping off part of the subject enhances this effect, so try to study his paintings. Adding a fisherman or seagulls not only gives life to the scene, but scale, too.

When it comes to painting, I am a strong advocate of painting en plein air. A subject like this touches all the senses, and working *in situ* is a good way of conveying feelings, rather than just images. I also seem to paint much quicker *in situ*, and produce 'fresher' and more spontaneous

COMPOSITION

Marine subjects are normally painted in a landscape format, but other formats can be challenging and more successful.

PORTRAIT FORMAT
Here the emphasis is on the foreground, with the tidepools helping to lead the eye

into the picture. I often use the colour, textures and abstract qualities at low tide, to add extra interest to a painting. Remember to avoid detail and keep foregrounds simple.

LANDSCAPE FORMAT
Good composition has a lot to do with balance and counterbalance. Here the background harbour wall plays an important part in the composition, with the mast also providing a dramatic link. Horizontals and verticals are known to produce a tranquil feel in compositions, while diagonals create more energy and movement.

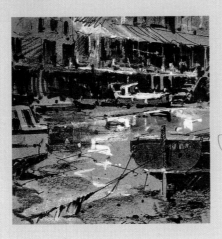

SQUARE FORMAT
In these compositional examples, I used a Canson Mi-Teintes pastel paper and drew in felt-tip pen and charcoal. The highlights were put in with white Conté crayon. You will find it less daunting than working on a white paper and it gives you an immediate tonal effect. Think counterchange – it will give rhythm and movement to a picture, as well as providing interesting contrasts.

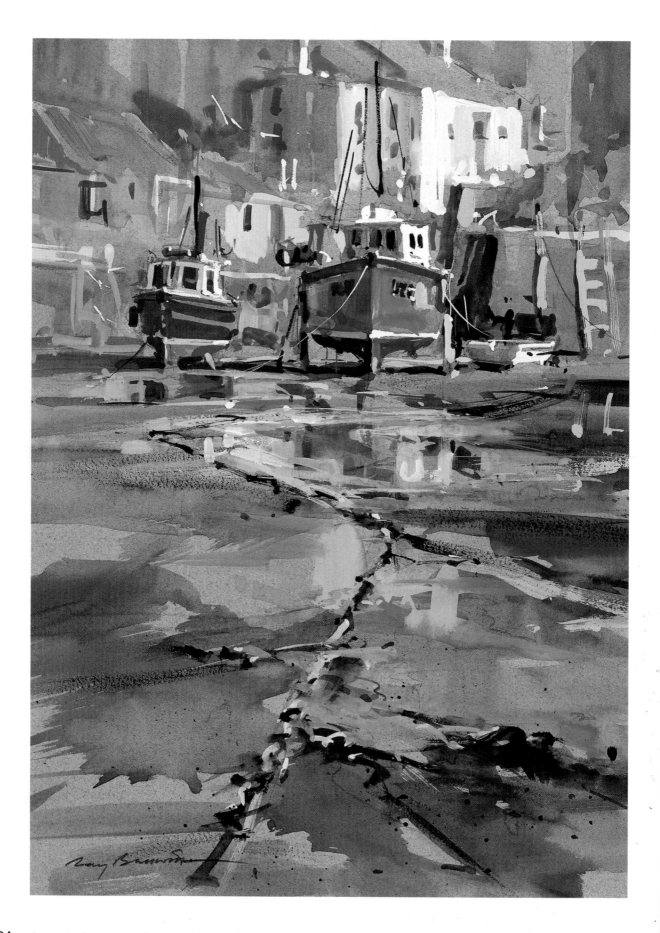

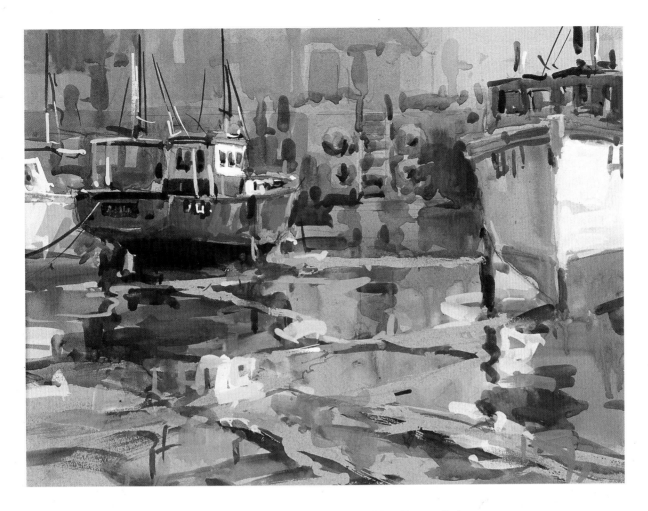

◀ Polperro Harbour

36 × 26 cm (14¼ × 10 in)

This quick colour sketch was done in situ. I used watercolour and white gouache on a tinted pastel paper (Canson Mi-Teintes — Moonstone). What excited me was the foreground, so I chose a low eye level, to lead the eye into the picture.

▲ Fishing Boats, Polperro

26 × 36 cm (10¼ × 14¼ in)

This colour sketch was done in watercolour and white gouache on a tinted pastel paper. I had to work fast as the tide was coming in very quickly. Although harbours at high tide can make a pretty scene, they are far more difficult to paint than those at low tide.

work than when I am in the studio. When I am working on a painting outside, I find it extremely useful to use a mount to help give me an overview of how the painting is progressing. I also always take a 30 cm (12 in) plastic ruler for checking that angles are correct. I can use it like a mahlstick for rigging as well as using it at arm's length for checking on horizontals and verticals.

It is important to get a feel for a place, speak to the fishermen, find out about its maritime history. To really get 'under the skin' of a place will take more than one visit.

6 BRIGHT IDEAS

Answered by:
Julie Collins

*My reds and pinks never seem to come out as bright as
I would like them to be. Can you help me?*

Watercolours always look much brighter when they are wet. Sometimes I mix a colour, put it onto my painting and while it is wet worry that it will be far too bright, Then, when it is dry it is fine, maybe not even bright enough.

Colour mixing is one of the most common problems people have with their watercolour painting – not just achieving the colour they want, but also the correct tone of that colour. There is nothing more disappointing than watching your watercolour dry too light. This chapter concentrates on improving your reds and pinks, but much of the information can be applied to all colour mixing.

Pink is my favourite colour – flower painters normally love their reds and pinks. If you like your subject you are more likely to succeed.

YOUR WATERCOLOUR BOX
I began watercolour painting using a watercolour box with a very limited palette. Having a small range of colours meant I could learn my way around my box fairly quickly. However, I did not realize that the box was set up as a landscape palette – as are most smaller watercolour boxes.

Tulip
24 × 19 cm (9½ × 7½ in)

REDS

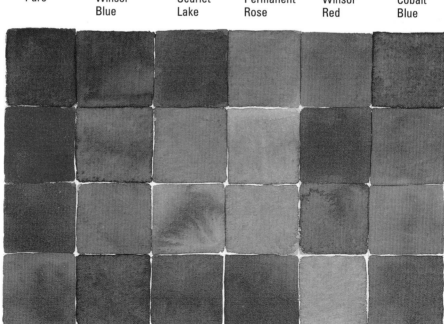

	Pure	Winsor Blue	Scarlet Lake	Permanent Rose	Winsor Red	Cobalt Blue
Alizarin Crimson						
Permanent Rose						
Scarlet Lake						
Winsor Red						

As a keen flower painter I would head straight for my Scarlet Lake to use for all pink and red flowers. This was fine for the hot red of a poppy, but disastrous for a delicate pink lily or bright pink fuchsia!

At that time I still used to think that I should 'mix a red and a white to make a pink', and it did not occur to me that it would be better to buy certain reds and pinks as they are impossible to mix. So the first question to ask yourself is 'Do you have all the colours you need?'. To be successful with your reds and pinks there are certain colours you must have.

The colours I recommend are:
- Permanent Rose
- Permanent Alizarin Crimson
- Winsor Red
- Permanent Magenta
- Winsor Violet
- Winsor Orange

Plus optional colours:
- Bright Red
- Rose Madder
- Quinacridone Red
- Quinacridone Magenta
- Permanent Carmine
- Rose Doré

USING COLOUR CHARTS

Getting back to basics by mixing and testing, and making charts of various pinks and reds will help you learn just how many there are. You can also modify a red or pink to make it cooler or hotter when required. For instance a slight amount of a blue with Permanent Rose will make a cooler pink. Remember, too, to make sure your tonal range from dark to light is wide enough.

See the charts shown here for some suggestions; you can make your own from all the reds/pinks in your box. It would be useful for you to make charts of the following:
- Bright or hot reds
- Bright pinks
- Pale or subtle pinks
- Cooler or mauve pinks
- Brick and autumnal reds

REDS AND PINKS 'COOLED DOWN'

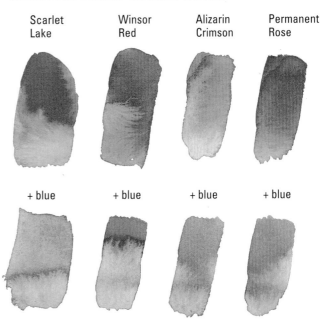

Scarlet Lake	Winsor Red	Alizarin Crimson	Permanent Rose
+ blue	+ blue	+ blue	+ blue

PINKS – DARK TO PALE

Permanent Rose + Winsor Red	Permanent Alizarin Crimson + Permanent Rose	Permanent Alizarin Crimson + Winsor Red	Permanent Rose + Quinacridone Magenta	Winsor Red + Quinacridone Magenta

BRICK AND AUTUMNAL REDS

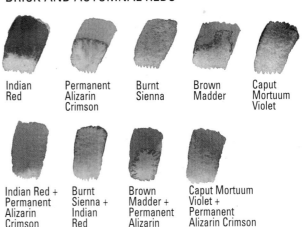

Indian Red	Permanent Alizarin Crimson	Burnt Sienna	Brown Madder	Caput Mortuum Violet
Indian Red + Permanent Alizarin Crimson	Burnt Sienna + Indian Red	Brown Madder + Permanent Alizarin Crimson	Caput Mortuum Violet + Permanent Alizarin Crimson	

HOW BRIGHT OR PALE?

If you are painting flowers from nature you will
see that many reds and pinks are extremely bright
and some are almost fluorescent. Sometimes this
is almost the opposite of the greens, which are
more subtle, and you may need to tone down a
green from your box, whereas your flower may be
almost straight Permanent Rose, apart from
shadow areas.

Illustrated here are several flower paintings
where I have used different reds and pinks in each
one. I can remember particularly enjoying doing
some paintings. This was the case with *Guzmania,*
where I derived so much pleasure from painting
the very bright reds. It was such a treat to apply
almost neat Scarlet Lake to parts of the flower and
not have to worry if the red was strong enough –
almost straight from the watercolour pan.

Guzmania
56 × 76 cm (22 × 30 in)

Orchid
19 × 14 cm (7½ × 5½ in)

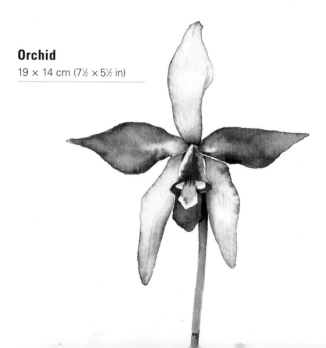

By contrast *Fuchsia* was painted using Permanent Rose, Permanent Alizarin Crimson and Winsor Violet. Here you can see that from a few of the colours I have mentioned you can achieve quite a wide range of reds and pinks that veer towards purple.

Then if you look at the pinks in *Alchemia* you will see that they are much more subtle and slightly grey in places. This flower was painted with the same colours as *Fuchsia*, but these were mixed much paler and also more 'candy' pink. Here the purple/blue and yellow/green in the leaves complement the pinks of the flower.

Orchid (opposite) was painted primarily using Quinacridone Magenta, which gives a slightly fluorescent quality to the colour. Lastly in *Tulip* on page 36 my reds palette was Permanent Alizarin Crimson, Winsor Red and some Permanent Rose.

PRACTISE MIXING YOUR REDS

On a recent course I was teaching someone who commented that, 'You have to be very disciplined to paint in watercolour.' This is very true as if you do not work in a methodical way you are likely to come up against more problems than you need to. So it is vital that when you have mixed your pinks and reds that you test them. Seeing the colour in the box or the palette will not tell you how it looks on your paper. Getting into the habit of testing your colours will avoid disappointment in your finished picture. Also, do not settle for approximations – keep mixing and testing until you achieve the exact colour you need.

Watercolour looks so intense when it is wet and I am still amazed when it dries and looks so much duller. Unlike an oil or acrylic palette it is impossible to guess what the colour will look like on the paper until you apply it as it may be far too pale, too bright or simply not the red that you want.

Finally, MIX PLENTY of each colour before you start! It can be difficult to match a mix exactly if you run out in the middle of painting. And take your time – it does not take long to paint, but any time spent preparing and practising your mixes will be well worthwhile.

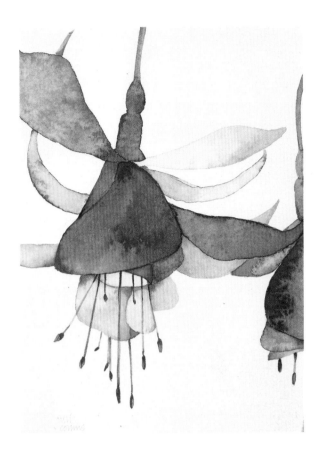

Fuchsia
18 × 12.5 cm (7 × 5 in)

Alchemia
56 × 76 cm (22 × 30 in)

7 FRUITS OF EXPERIMENT

Faced with a blank sheet of paper, I seem to run out of ideas.
How can I find inspiration for a painting?

Answered by:
Anuk
Naumann

Sometimes nothing seems to go right. It is raining and windy outside, so you have to give that sketching trip a miss, the light is not good enough and anyway you have run out of inspiration. It seems that the way you have been working for some time is stale and uninteresting. You need a new injection of excitement into your painting, to create something that you feel is different and yet individual, but staring at the piece of white paper does not seem to provide the answer.

As artists, most of us have felt this way at some time. When I feel that I am getting into a rut and need a new direction I try to investigate various ways of working, using a theme. I usually begin with watercolour, then work through to mixed media and collage. I try to explore different routes and usually find some exciting new pathways and diversions. I can add these to my repertoire of methods and techniques, saving them up in my mind for when I am next stuck for an idea.

Pears in the Studio
20.5 × 20.5 cm (8 × 8 in)

▲ Pears and Blue China
sketch, watercolour crayon

►Studies of Pears I
watercolour crayon

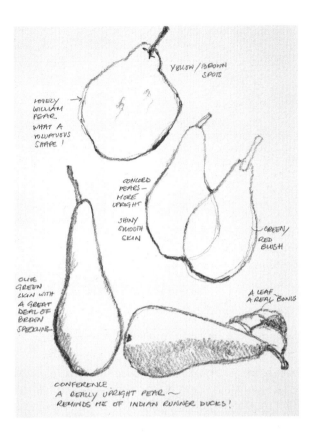

YELLOW/BROWN SPOTS

LOVELY WILLIAM PEAR. WHAT A VOLUPTUOUS SHAPE!

CONCORD PEARS — MORE UPRIGHT

SHINY SMOOTH SKIN

GREEN/ RED BLUSH

OLIVE GREEN SKIN WITH A GREAT DEAL OF BROWN SPECKLING

A LEAF A REAL BONUS

CONFERENCE A REALLY UPRIGHT PEAR — REMINDS ME OF INDIAN RUNNER DUCKS!

A STILL LIFE WITH PEARS

When faced with the dilemma of what to do and how, I usually turn to still life, as it is a subject over which I feel I can have complete control, from the initial composition of my chosen objects, to vantage point and, to some extent, lighting.

I love pears. The very shape of the fruit is distinctive, and the range of different types of pear, from Comice to Red Williams, gives a wealth of artistic possibilities. The following examples will all show some way of interpreting a still life with pears, but the principles can be applied whatever subject you choose to portray.

So, where to start? The still life is set up, the blank page is still fixed expectantly on the easel, willing some response. The answer for me is to begin sketching, not with a graphite pencil but with watercolour crayons, which can, if needed, be translated into a final painting. Taking time to set up the composition allows me to start the thought processes as to how to tackle the final work, and then with a series of sketches I can explore the possibilities.

In the sketch of *Pears and Blue China* a 'taking my pencil/crayon for a walk' technique has been used, where the line is created in one, almost continuous movement, not taking the pencil away from the paper. This can sometimes help to discover if the pieces in the composition have been well placed, or whether uncomfortable jumps need to be made, which might be difficult on the eye. Following from this, I can prepare the paper for a watercolour interpretation of the set-up, making small adjustments where necessary.

In *Pears in the Studio* (opposite), some of the same elements appear as in the earlier sketch, although I have cropped the page to fit the still life more closely, losing some of the foreground. I often use this device of cropping once a painting is finished, and have cut a number of shapes and sizes of 'viewfinders' out of mountboard, which helps me to assess just how I want the composition to look. This method of using a viewfinder can also help enormously in getting started with a composition, and can determine whether you want to paint your picture in landscape, square or portrait layout.

In this watercolour painting I used squirrel brushes loaded with colour. By using tubes instead of pans of paint I am able to get a rich

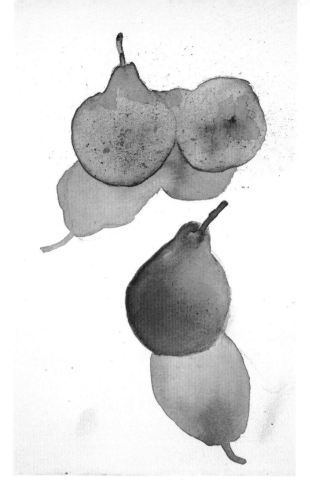

Studies of Pears II
watercolour and crayon

pigment into the painting. Because the paint is applied very wet, it is necessary to work with the paper laid horizontally on a board. In this way, a certain distance and change of orientation is forced upon me, which makes me look at the work I am producing in a separate way from the subject. The very action of having to look up at the subject, then down to my work, creates an element of detachment, and I begin to regard the process of painting as a means in itself: playing around with colours and spaces, creating patterns and loosening up the feel of the composition. In this way, the design of the finished piece becomes important, and the subject acts as an *aide-mémoire* rather than a slavishly copied portrait.

INDIVIDUAL STUDIES

But what if you have bought or picked your pears and still have no inspiration to create a complete still life? Just enjoy observing the characteristics of the fruits themselves and make a series of individual studies of pears. These will stay in your sketchbook as reference for later.

In *Studies of Pears I* on page 41 I started to examine some of the different qualities of the various types of pears, noting the shapes and colours, but keeping to a simple rendering in Sepia watercolour crayon.

Studies of Pears II shows two different renderings of Williams pears, the first loose and sketchy, the second more deliberate. For the yellow, ripe Williams pears (top) I used a loose wash of Aureolin and Yellow Ochre, laid over a Sepia crayon drawing. As the very wet pigment of the wash dried and took up the crayon, a darker 'rim' appeared around the painting, which gave a satisfactory edge, but kept the painting in two dimensions. A spattering of drier paint from a toothbrush added texture and the effect was complete. However, with the single pear (below), this time a greener, firmer fruit, I used a series of glazes or fine washes to create a rounded three-dimensional pear that looks as if it could be plucked off the paper and eaten. Here I used very thin washes of colour, starting with a pale Lemon Yellow and building up until I achieved the required depth. Each wash was allowed to dry completely, and the paper misted before the next layer applied. This can be a painstaking method, but really lovely effects can be achieved, and the fruit seems to glow with an inner light.

BOLD EXPERIMENTS

One you are satisfied for the moment that you have made enough studied observations of your subject, begin to play with the paint itself; see what you can make the watercolour do for you. Start by laying loose washes, leaving these to dry and adding texture. Play around with different ways of mark making, using wax and oil pastel as resists, blotting and stamping with kitchen paper and plastic film – the possibilities are endless. Let your imagination get carried away in the variety of ways the watercolour can be used to interpret the fruit. Do not just use realistic or natural colours to represent the pears; experiment with bold combinations of colour, and with complementaries to get exciting effects.

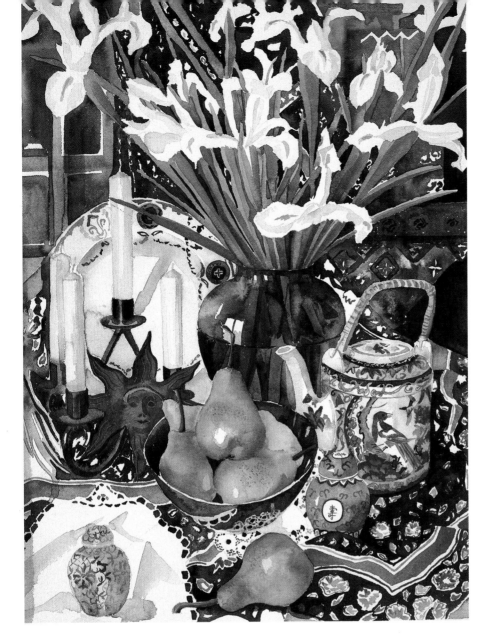

White Irises and Pears

61 × 40.5 cm (24 × 16 in)

Using watercolour wet-in-wet can be tricky, but exciting and the resulting runs can be used to enliven your work.

Now, take notes. Whether during the process of mark making, or soon after, jot down how you got the results you have achieved. Much painting, particularly watercolour, seems to happen as a happy accident, and if you want to recreate the effect, it helps to have some record. How often have you asked yourself, when looking at a painting some time after it was finished, how you achieved that effect? If you have a well-notated sketchbook you can save a great deal of time.

Looking at your notes and sketchbook, and reviewing the variety of different techniques you have tried should whet your appetite for tackling

a more complicated painting. In *White Irises and Pears* (above) the pears themselves form a relatively small proportion of the whole painting. However, they are placed on the central axis of the picture and are a similar colour to the stems of the flowers, so make the eye move up and down the painting and provide a link between the elements. Using very wet brushes loaded with pigment, I moved from section to section around the work to complete the whole, taking care to consider the background at the same time as the rest of the picture. The painting, although busy, is controlled, and was executed with care, ensuring each section was dry before painting the next. As a contrast, and using a freer approach, *Provençal Pears* on page 44 has fewer defined edges; no drawing was done

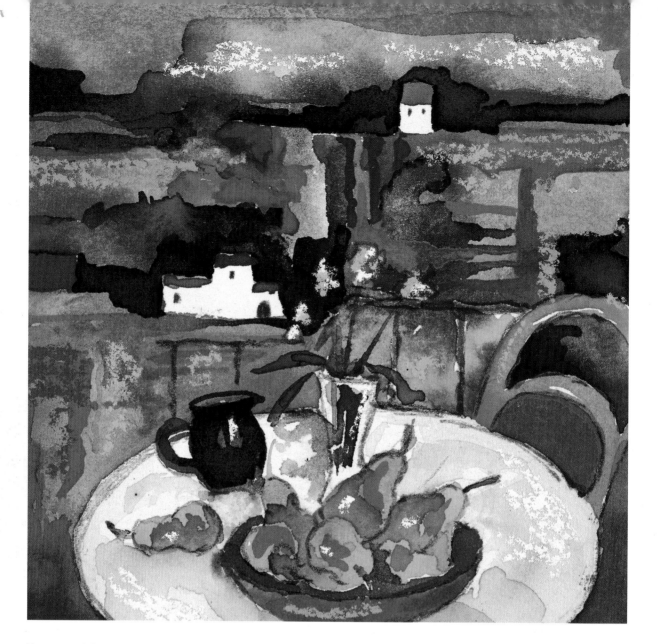

Provençal Pears
watercolour and crayon, 20.5 × 20.5 cm (8 × 8 in)

beforehand, and several different, loose techniques were applied to get the finished effect.

Although, once again, I applied the paint very wet, and with a good deal of pigment, I allowed drips and runs by tilting my board while the paint was still wet, to see what would happen. Blotting areas to reduce the amount of paint and allowing colours to run into one another using a wet-in-wet technique all help to achieve a looser approach. The pears now form part of a landscape, thus moving away from the set still life, and the drawing of the fruit is sketchy rather than closely representational. A final touch, which brings us full circle and demonstrates the need to be constantly looking at different ways of dealing with the medium, is the use of the watercolour crayon. This time, instead of starting the painting by underdrawing with watercolour crayon, I added lines of crayon on top of the dry painting.

All these examples reveal different ways of using watercolour, in pans, tubes and watercolour crayons. Experimenting with different ways of using these materials produced varying results. But with a few strokes, *Provençal Pears* enters a new realm. Once the wet painting was completely dry I applied a few strokes of soft pastel, providing texture as it breaks up on the rough paper and taking us into the exciting and stimulating world of mixed media.

8 DIRECTIONAL POINTERS

How can I achieve a focus in my paintings?

Answered by:
Gerald Green

Without a clear focus paintings can appear vague or ambiguous. The artist must create a well-defined centre of interest in a painting to which the eye will be led. Beginning with a simple, clear concept is the best approach, but it is very easy to lose sight of this during the painting process by becoming distracted into resolving a painting as a series of separate parts, rather than continuing to see it as a whole.

ABSTRACT SEEING

Always start by giving yourself time simply to observe your chosen subject. It is essential before committing brush or pencil to paper that you have a clear idea of exactly what it is you want to portray. Look particularly for its abstract qualities, the characteristics of form, shape, line, pattern and texture, since these are the visual features that you will need to translate into your paintings. For example, rather than seeing a potential subject as simply an attractive bowl of flowers, what you might find most alluring about it could be the particular relationship between the different coloured flower shapes or their contrast with the darker textured patterns of the leaves. Or what first inspired you to paint a view of two trees on a bend in a river might be described in abstract terms as the contrasting colours of the reflected patterns in the water made by the overhanging trees. Descriptions like these will clarify your visual response and direct you towards a more focused interpretation.

The next step is to decide which elements are essential to support your interpretation, and which could be left out altogether. Ultimately, what you choose to omit will be as influential as what you decide to put into the painting. With a

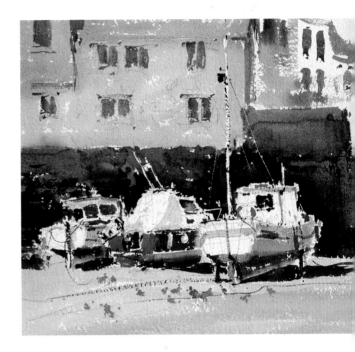

Boats at Polperro
30 × 35 cm (12 × 14 in)

Strong tonal contrast draws attention to the centre of interest. I painted the boats negatively, allowing them to remain as white paper, describing their shapes by carefully painting around them with the strong dark mass of the partly shaded building behind.

clear idea of what you want your painting to be about, you can construct the image to draw attention to your chosen focal features, which can be enhanced with combinations of directional pointers: line, tone, colour and mood.

LINE

Lines imply edges, and edges are generally what are defined in drawings. A simple definition of

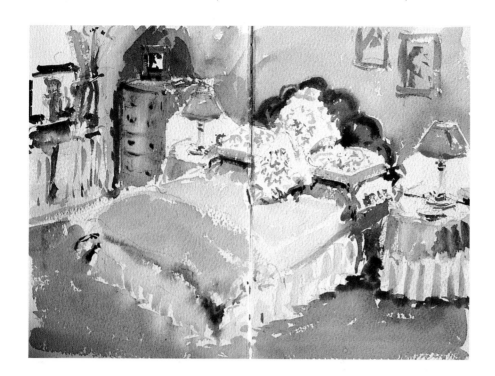

Cottage Bedroom

Hard and soft edges can also be used as directional pointers. I used hard edges to draw attention to the centre of interest, which I also combined with the high tonal contrast of the white paper itself. The soft edges to the base of the bed are less noticeable.

linear composition is drawing elements where they look 'right' in an image. So the first essential is to set out a composition that will draw attention to the centre of interest. You can achieve this by using the general rule of dividing your picture surface into thirds, both horizontally and vertically, and locating the dominant elements at points where these lines intersect.

I also tend to favour the slightly different proportions set out in the Golden Mean, which is defined as a ratio of 1 to 1.618, but as a rule of thumb the proportion of 2 to 3 is a satisfactory approximation. Provided you locate your principal features somewhere between these two ratios, this will allow you to begin to design an image based on a well-balanced linear structure.

Linear perspective is another useful directional aid, providing the basis for creating three-dimensional space, depth and distance. Elements in an image can also be invisibly held together by locating them within linear shape motifs, usually triangles, circles, or ellipses.

TONE

Similarly, tonal values can be used as an effective directional pointer. Lights and darks are instrumental in describing the basic three-dimensional forms in a painting and create the impression of light and space. The greatest tonal contrasts, white against black, being harsher on the eye, are more immediately noticeable and will tend to advance, while the more subtle intermediate tonal changes tend to recede. Areas of the greatest tonal contrast can thus be used to draw attention to more dominant elements.

Edges also provide directional accents, with softer-edged shapes appearing less severe than hard-edged forms. You can further enhance dominant elements by combining hard edges with strong tonal contrasts. In *Boats at Polperro* on page 45 the eye is directed to the group of boats by using the greatest tonal contrast, coupled with the hardest edges. *Cottage Bedroom* combines both hard and soft edges. Notice how the eye is immediately drawn towards the harder-edged shapes. When these features are used in conjunction with line, this will further accentuate the directional effects.

COLOUR DYNAMICS

Adding accents of pure colour is another effective means of drawing attention to areas in a painting, although this will only work successfully when the colour is used in a coordinated way. Perhaps the simplest method is to use a limited palette of colours against which individual touches of new, purer colours can be set.

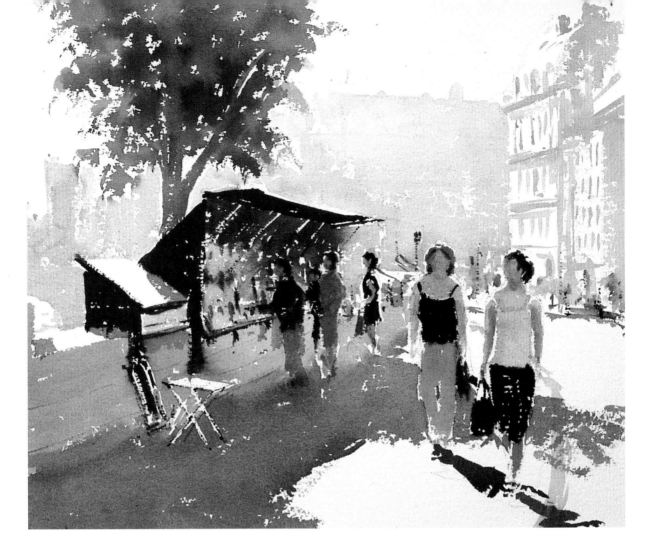

Contrasting shapes within the general patterns of an image can also direct the eye around a painting. Using them in combination with dynamic colour passages will increase the impact.

MOOD AND ATMOSPHERE

Mood is a rather elusive quality since it depends upon feelings. Although we all recognize it when we see it, creating a predetermined mood or atmosphere in paintings requires the precise manipulation of both colour and tonal values. To understand how colour influences mood think of looking at the world through pieces of different coloured perspex or glass. Here a dominant colour will pervade the entire view, creating the feeling of chromatic light or mist and altering our perception of the subject.

In *Strollers by the Seine, Paris* I wanted to create the feeling of a hot sunlit day. Here the atmosphere of looking into the light is created with tonal counterchange rather than colour. Lights and

Strollers by the Seine, Paris
26 × 37 cm (11 × 15 in)

I divided the surface to give a satisfactory linear composition with the lines of the road edge, wall and edges of the ground shadows, creating directional pointers into the picture. Strong foreground colours against muted, less-defined background forms, give the illusion of distance.

darks are exaggerated, with areas receiving the light being lifted in value and shaded areas becoming darker, some reduced to silhouettes against the light. Strong directional ground shadows reinforce the feeling of light and also work as linear pointers directing the eye into the image. To augment the impact of the focal foreground figures I loosely described the background forms in a fairly understated manner.

All directional pointers are, of course, interdependent and can be incorporated within any subject matter.

9 THE BLUES

How can I choose and mix the right blues when painting skies and seascapes?

Answered by:
Tom Robb

There is much pleasure and profit to be gained from learning how to mix individual colours, and from understanding the characteristics of each pigment and how these affect the behaviour of the paint on the paper.

Historically, pigments were produced by dissolving or grinding minerals, plants or insects. These colours were often unreliable; they sometimes faded quickly and, far more annoying to the artist, they could vary from batch to batch. In addition, although this was not always realized, some were toxic, and over a period of time could affect the health of both manufacturer and user.

Today, although there are still many natural pigments in constant use, synthetics can be formulated to give consistent results, and a better degree of lightfastness. There are also new colours that would have been unobtainable from natural sources, and that have added enormously to the vibrant quality of the modern watercolour palette.

As well as lightfastness another defining characteristic to consider is whether the pigments are granular or staining. Granular pigments stay slightly gritty even after being dissolved in water, while staining or dying pigments saturate the water much more consistently.

There are also varying degrees of effectiveness within stains. Prussian Blue, for instance, is a virulent colour that dominates almost anything else, and has to be used extremely carefully.

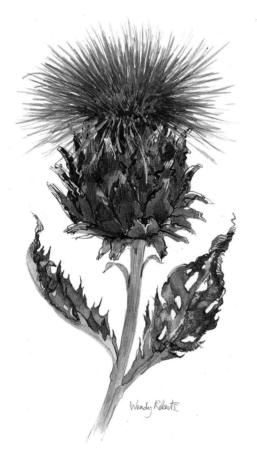

◄ **Cardoon Flower Head** (Wendy Roberts)
11½ × 8 in (29 × 20.5 cm)

A carefully constructed flower with fine detail and sharply defined brushwork in a warm blue moving towards purple. In fact, there were many blue mixes used to achieve this stunning effect. Coeruleum and Permanent Blue were modulated with Violet and Payne's Grey, Cadmium Red, Permanent Rose and Venetian Red.

▶ **Portuguese Creek**
40.5 × 30.5 cm (16 × 12 in)

In this coastal sketch there are three blues. The sky and foreground of the sea are Cobalt Blue, the area near the boat is French Ultramarine, and the darkest band — almost black — is Prussian Blue. The three colours are used to give distance as well as showing off the variety you can achieve by blending them into each other.

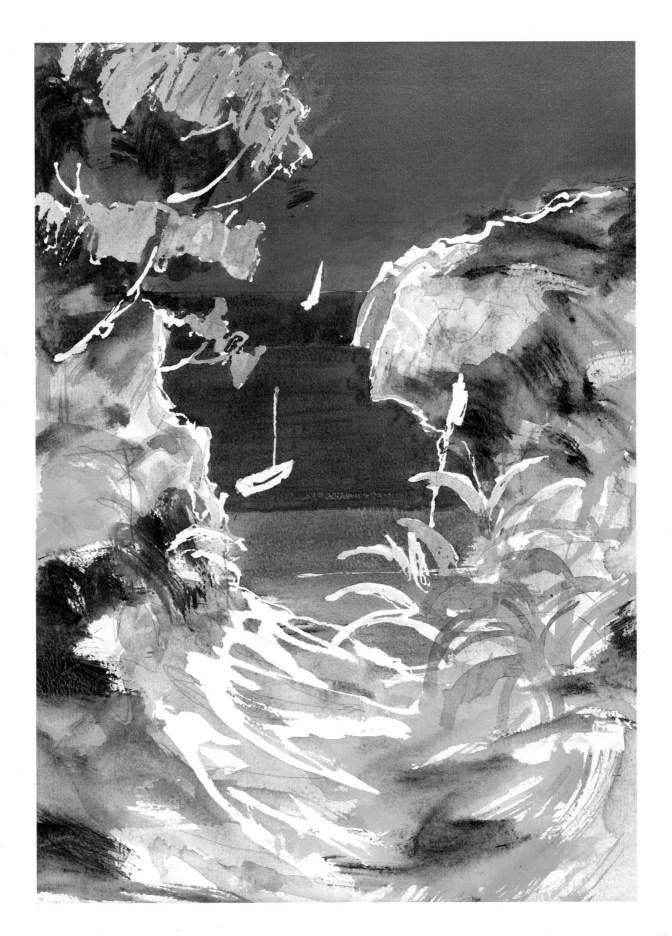

Lavender Fields

42 × 30 cm (16½ × 11¾ in)

One could hardly have a more simply blue painting than this. French Ultramarine covers most of the paper, as the flowering plant is here more blue than the common purple lavender. The depth of colour is captured in the variety of brush strokes, which build up the texture. French Ultramarine is also used in washes for the sky, so the entire painting is achieved with a single colour. Only a small addition of Lemon Yellow enhances the contrast and makes the blue look even more vivid.

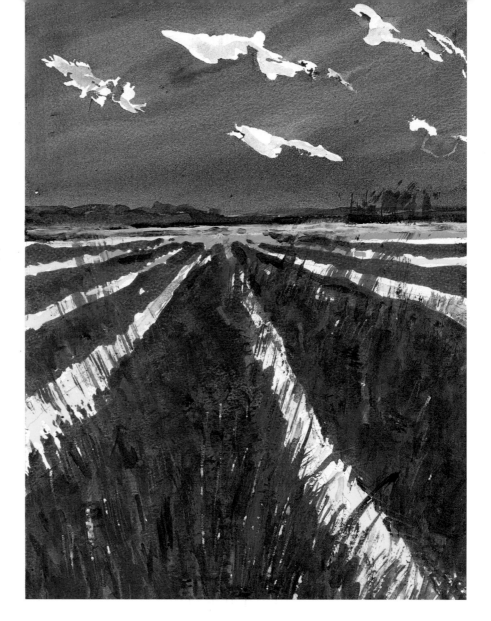

MIXING COLOURS

Today's standard colour mixes bought ready-made can be compounded quite differently by the various manufacturers, so it becomes important to make a note of what ingredients are listed on the manufacturer's paint chart. In any case, learning to check the manufacturer's chart will often be a great help.

A basic rule has always been that you start with the lightest colour and add the darker one in small increments until you achieve the desired result. But even this needs some care – Cadmium Red and French Ultramarine, for example, might seem to have much the same intensity. So this is where it is important to know about the underlying opacity and transparency of individual colours. In fact, Cadmium Red will have a higher opacity rating, so you must begin with the blue and add the red drop by drop.

Try to keep your mixes to two colours to avoid a muddy result. Three colours should be the limit, but if you have to work with four colours, then it must be literally drop by drop. Again, checking the manufacturer's chart will be useful; many of the bought colours are already mixes. For example, Olive Green is usually made up from two or three colours in varying quantities, so adding even two more will give you mud green!

Remember, too, that there are often new mixes and new colours coming on to the market. Do not be afraid to try other colours that you personally find attractive or useful to your own style and choice of subject. Experiment with mixes of these new colours to discover their potential.

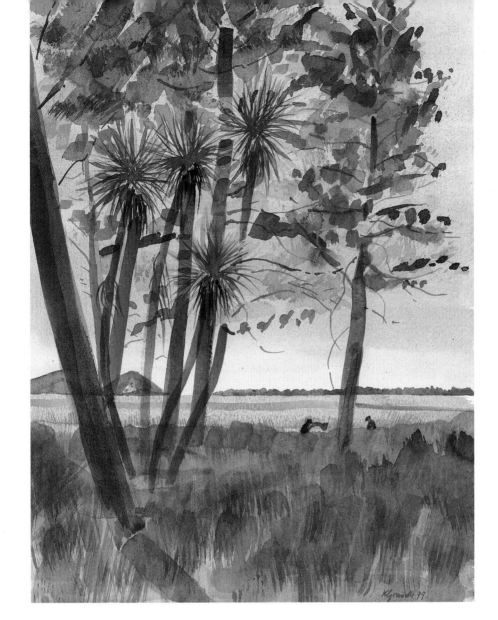

Tauranga Harbour, New Zealand
(Keith Graville)

39 × 30.5 cm
(15½ × 12 in)

An unusual place with unusual trees, this is painted against the light and shows how Phthalo Blue with a warming trace of Raw Sienna can give the artist just enough to capture such a scene successfully. The sky and foreground were washed in first, killing all the white of the paper. The trees and the foreground shadows were then painted in with more Phthalo Blue.

SKIES AND SEAS

Blues are vital colours for sky and seascapes, and important with most other subjects, too. Blues were originally made from plants and the semi-precious lapis lazuli gemstone.

Coeruleum A pale blue with a definite green tinge, this creates a basic sky. Relatively easy to lift, and not very opaque, Coeruleum translates well into many transparent mixes, and is especially useful for adding to greens.

Cobalt This is a colour which has been around for over 4,000 years, used in ancient Persian glass and pottery. Medium strength, it is a lovely clear blue with a granular texture that adds depth to any wash. Helpful for delicate sky colours.

French Ultramarine First developed in the laboratory at the beginning of the nineteenth century, this was intended to replace lapis lazuli, which was already too expensive for most artists. It is marvellously transparent, yet gives good covering power. If you have to choose to take only one blue with you on a painting trip, this is the one.

Prussian Blue A bully shouldering out anything else in a mix, so use it with absolute discretion. Yet its sharp, greeny-blue substance is invaluable and irreplaceable. And, yes, it was first made in Prussia, in the eighteenthth century.

Manganese Blue An unusual colour, only slightly green. Perhaps difficult to use in mixes because it tends to separate, it can add depth and texture to the wash. Lightfast, it is easy to lift, so it works well for background washes where you want to include areas of white or other colours.

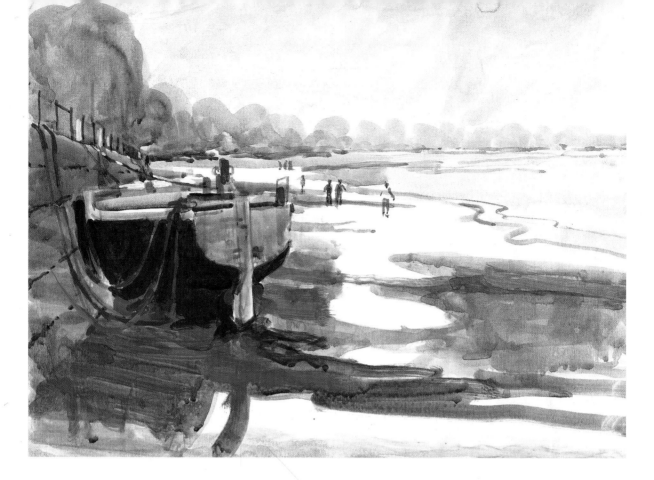

Boat by the Thames
30.5 × 40cm (12 × 15¾ in)

Prussian Blue should be used carefully with other colours as it can so easily get out of hand, even with experienced artists. Here, though, the sketch is almost monochromatic, with only a touch of Yellow Ochre to tone down the acidity. Extremely effective, pure Prussian Blue was used to achieve the shadows in the boat.

Indigo From the famous and well-known plant, genuine indigo is still one of the great pigments, its greyish tone unmistakable and essential for painting night skies.

Phthalo Blue The most modern of these blues, which has come into its own only in recent years. This colour is beautifully transparent, and mixes evenly and cleanly.

Turquoise A man-made colour that imitates the stone from which it was once produced. Like the original, it can be more green than blue, or more blue than green, depending on the manufacturer.

I find it essential for seascapes, especially for shadows in grey-blue waters, but I also use it regularly in flower studies.

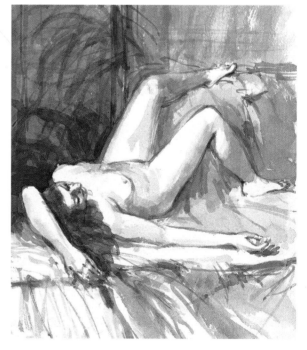

Reclining Nude
29 × 24 cm (11½ × 9½ in)

A different way of using blue creates a soft life study drawn with a brush. Coeruleum, delicate enough by itself, is subdued even more by adding a little Payne's Grey.

10 GO WITH THE FLOW

How do I get running water to 'move' over rocks and stones?

Answered by:
Barry Herniman

Flowing water can be a very emotive subject, but problems can arise for the artist because it is doing just that … flowing!

The mere indication of a waterfall on a map is enough to get me trekking for miles to catch the view of cascading water. Large or small, falls all have their own magical qualities and provide a source of energy in the landscape. Water rushing over a precipice takes on an ethereal quality as it begins its descent, almost floating as it meets the water beneath it. For the watercolour painter this is a challenging subject.

Most landscape subjects are fairly static. Skyscapes can be very transitory with moving clouds that change the scene minute by minute, but a fast-flowing stream moves more rapidly and, to the untrained eye, a lot more haphazardly.

Tregate Bridge
35 × 53 cm (14 × 21 in)

The first time I visited Tregate Bridge the River Monnow was in spate and the round hole on the right was half full of water. On a subsequent visit I was confronted with an altogether calmer scene. I was able to climb down to the water level and look back at the bridge. There is a flat millpond character to the river before it starts to move more rapidly over the rocks in the foreground.

Demonstration: Stage 1

I drew in the main outlines of the composition — the rocks, tree lines and the position of the waterfalls — with a 2B pencil. Masking fluid was applied to retain the white highlights of the water and a couple of the main rocks.

Stage 2

With the highlights reserved, I was able to drop in a strong wash of slatey blue for the whole water area. The background falls were laid in fairly weakly, building up the strength as I worked forward. Care was taken when painting around the rocks as it would be difficult to lift out unwanted colour afterwards.

Flowing water provides a subject of constant movement, change and, depending on the prevailing weather conditions, intense energy.

Initially the scene is one of indiscriminate movement, but if you stop and observe it for a while a pattern emerges, with the swirls and eddies repeating themselves over and over.

RECORDING THE SCENE

A camera is a very useful reference tool for recording moving water, but it has its limitations. Photographs taken with fast shutter speed show the scene in precise detail, freeze framing it in a split second, but the movement is actually lost. If you slow down the shutter speed the water takes on a blurred appearance. Using both these types of photographs, however, can be helpful by giving a clear reference on the one hand and a dynamic 'flow diagram' on the other.

Producing preliminary sketches on the spot will sharpen your awareness of the subject as you look into and study the underlying patterns made by the moving water. Observation is a key factor here if you wish to produce a painting that represents the fast-moving scene in front of you with any conviction.

Use your watercolours dynamically to depict the flow and movement of the water as you paint the scene. You can actually move the watercolour over the rocks as the running water would in real life, tilting the board to guide the paint in the direction of the flow.

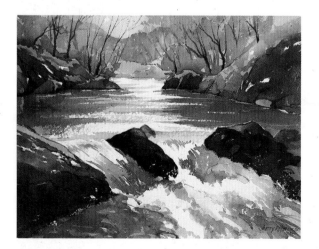

Direct watercolour
24 × 34 cm (9½ × 13½ in)

This quick watercolour was done as a demonstration for one of my classes and was painted quickly and directly without any masking or preliminary work beforehand. I was careful to paint around the white highlights while still getting a lot of movement in the brushstrokes.

Stage 3
After this initial wash had dried I removed all the masking fluid and painted in the trees and the rocks.

Stage 4
A small bristle brush was used to soften some of the harsh white marks left by the masking fluid. Using clean water I also lifted out some highlights from the rocks. With a darker mix of Burnt Sienna, Raw Sienna and Prussian Blue, I began to bring out detail in the surrounding rocks.

Finished picture: Aysgarth Falls, Yorkshire Dales
22 × 30 cm (8¾ × 12 in)

I mixed a fairly dark wash of Prussian Blue with a touch of Aureolin and Burnt Sienna. After wetting the areas just above the fall lines, I dropped in darker accents using this mix. Some colour flowed over the white highlights.

The shadow areas on the falls were brushed in with a weak blue-violet mix. A flat wash of highlight blue was applied to the sky. The trees were given a stronger second wash to bring them forward and more detail was added to the foreground rocks. Using the pale blue-violet wash, I finished by knocking back a few areas of the white water.

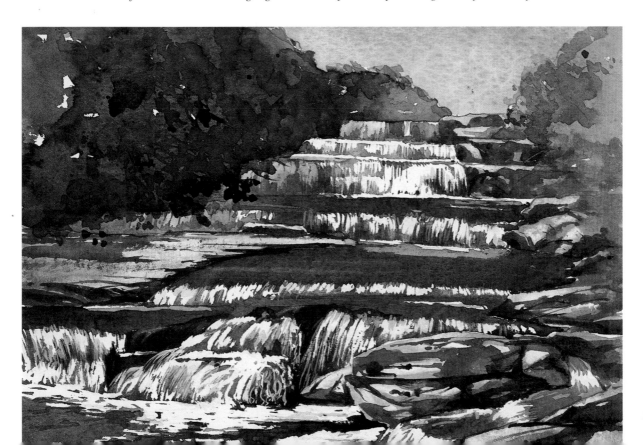

11 BEYOND THE LIMITS

The huge range of colours that are available is bewildering. How can I choose which ones to buy?

Answered by:
John Lidzey

Count the number of colours on a typical artists' paint manufacturer's chart and you are likely to find well over a hundred. It is not surprising, therefore, that some newcomers to painting are bewildered by the prospect of making a choice of paints. One manufacturer offers 15 yellows and 11 blues, some of which look the same as each other

on the chart. There are even ten colours that could roughly be called 'brown'. You might ask whether all these 'browns' are necessary, especially as many people's attempts at mixing other colours often finish up as brown anyway.

One way of choosing a set of colours might be to pick those which the local art stockist has run

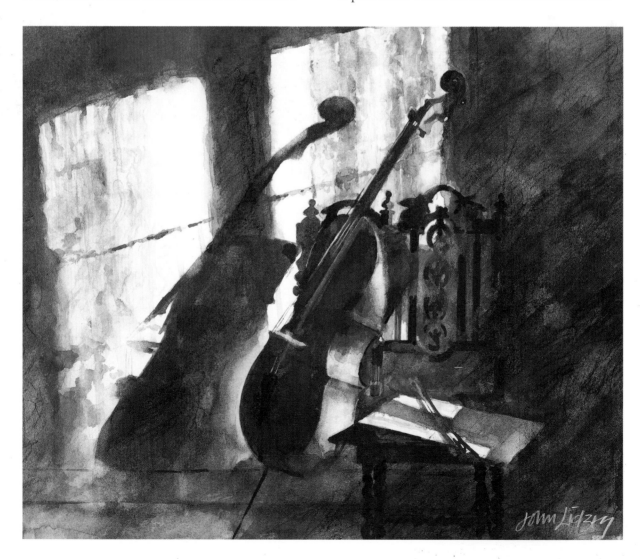

out of, on the basis that these are the most popular and must be the best ones to have. Another way is to buy one tube (or pan) of each colour in the range! But there is an alternative method that is much more cost-effective.

LIMITED COLOURS

For peace of mind as well as your pocket keep your watercolours to a limited range, especially if you are new to painting. It is better to have no more than a dozen or so watercolours in your painting kit. This will enable you to get to know their capacities, how they combine with each other, how they tint out with water, their transparency or opacity, their staining characteristics and whether they granulate or not.

A painting kit containing a large number of unfamiliar colours will make painting more difficult. It is possible that you might mix two colours together to produce a third and be disappointed with the result. Yellow and blue do not always make green, and red and blue do not always make violet. With a reasonably limited colour range you will at least know what two specific pigments mixed together will look like.

A BASIC SELECTION

For a balanced set of colours you need at least warm and cool versions of yellows, reds and blues, plus one or two neutral colours. Warm and cool colours have characteristics that give them a particular colour temperature. Cool yellows incline towards the green end of the range, while warm yellows look more orange. Cool blues are more greenish and warm blues more reddish (violet). Cool reds have a blue bias and warm reds also look more orange. Neutral colours can be classified as blacks, greys and some low-toned umber colours.

◄ Cello in Sunlight
35 × 50 cm (14 × 20 in)

This painting was produced using Monestial Blue, Indigo, Cadmium Red and Yellow Ochre with an additional light scribbling of Conté crayon. The simple and restrained colour adds to the dramatic effect produced by the light shining on the wall.

▲ Flowers in the Window
33 × 23 cm (13 × 9 in)

Wild flowers gathered from the hedgerow can make an arrangement every bit as good as cultivated ones from the florist. Painting flowers against the light can be a good way of suggesting colour and tone. For this picture I used the basic colours I have suggested below.

A good set to have for general use might contain the following colours: warm yellows – Cadmium Yellow Deep, Yellow Ochre, Cadmium Yellow Pale; cool yellows – Aureolin, Lemon Yellow; warm reds – Cadmium Scarlet, Cadmium Red; cool reds – Alizarin Crimson, Winsor Red; warm blues – French Ultramarine, Winsor Violet; cool blues – Prussian Blue, Coeruleum; neutrals – Burnt Umber, Payne's Grey, Indigo; plus Titanium White gouache.

With these colours you can mix a wide variety of hues: greens, violets, oranges, browns, greys and even warm and cold blacks. Mixes from these

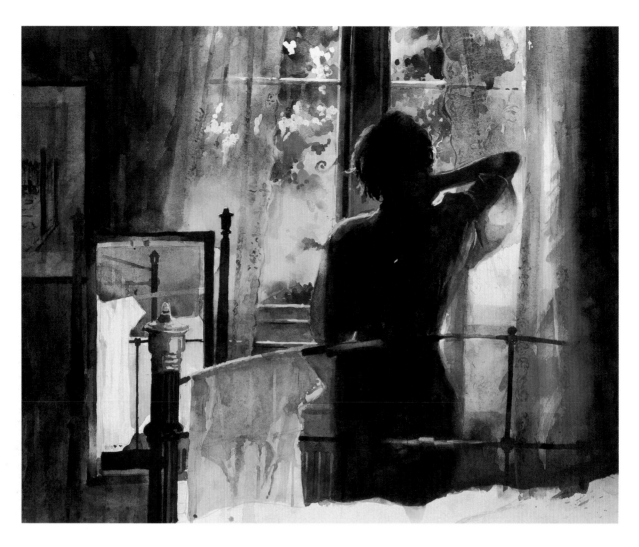

Bedroom at the Dell
41 × 53.5 cm (16 × 21 in)

*Strong tonal values here create a sense of light and shade.
In this painting only four colours are used.*

colours will not give you every colour in the
visible world, but they will enable you to create all
you are liable to need for most subjects.

Flowers in the Window on page 57 was produced
with mixes from the colours I have suggested. In
this still life there are some strong colours
together with a number of quite subtle ones. The
painting demonstrates that bright colours can be
created from mixtures of other colours and they
can be heightened by being set in the context of
sombre tones. The colours in the left, right and
base of the picture have been carefully modulated
to achieve this result.

COLOUR AND SUBJECT MATTER
The colour of things we see in the visible world
does not remain constant. Grass that looks green
at midday can look yellow in the evening sun; my
hand, which looks pinkish in daylight, can look
dark brown if I hold it up against the window. Late
in the day before the sun sets my garden colours
become much more muted. However, many
artists use colour not to describe the colour of
things as they appear to the eye, but as a means of
interpreting the world in terms of their own
personal vision. A well-ordered palette of limited
colours is one of the means of achieving this. A
painter who has resource to too many colours
only invites chaos.

Having finally decided on your colours it might
be a good idea to attempt some paintings in just a
few colours. This has the advantage of releasing
you from the problem of finding a match for the

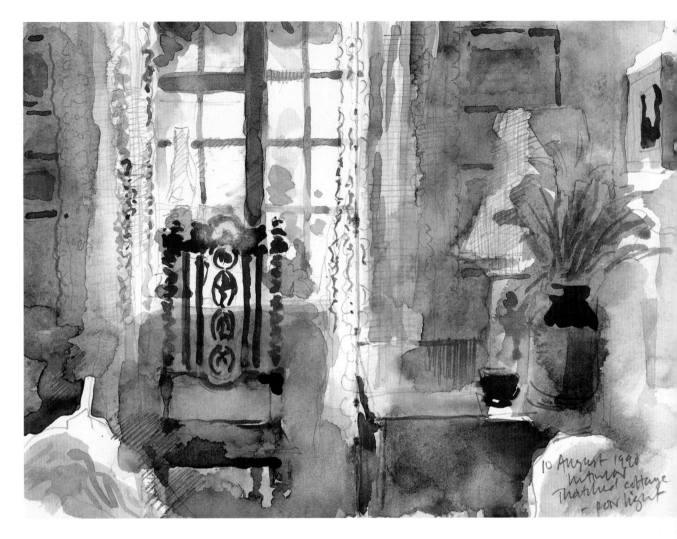

colours in your subject. Also, the work you produce could have a quiet, harmonious quality, which can exude a feeling of peaceful tranquillity.

PAINTING WITH FOUR COLOURS

One of the rooms at the Dell (*Bedroom at the Dell*, opposite) faces east, and the early morning sun creates some interesting effects. The room is quite dark, but the light picks out some small patches of colour in the room. This is an ideal subject for a restricted-colour painting.

I used four colours to create the effects I required: French Ultramarine, Yellow Ochre, Cadmium Red and Indigo, plus a few touches of white gouache. The painting was built up with soft washes of colour. The tonal values were gradually strengthened as the work progressed. The warm yellow-red of the item of clothing in the foreground was painted with a very dilute

Cottage Interior – Study
23 × 30.5 cm (9 × 12 in)

Three colours were all that were needed to suggest this quiet, peaceful interior. The paint was applied freely and loosely in overlapping washes. Payne's Grey was used to extend the range of tones in the painting.

Yellow Ochre and Cadmium Red mix. The more shadowy parts of the painting made use of the same mix with a touch of Payne's Grey added. The hint of colour outside the window is suggested with splashes of Yellow Ochre set against some foliage painted with mixtures of Yellow Ochre, Indigo and French Ultramarine.

The quality of light is mainly created by the use of strong tonal contrasts. Remember that well-developed tonal values can make a painting work even though the colours used are few.

PAINTING WITH THREE COLOURS

Take a colourful subject which has a wide range of tones and paint it using three colours only. Use paints that lack any colour intensity. One possible combination is French Ultramarine, Payne's Grey and Yellow Ochre. With these colours you can make interesting tonal studies similar to *Cottage Interior – Study* on page 59.

The best procedure is to view the subject through half-closed eyes. This will enable you to concentrate on tonal values as distinct from hues.

Watering Can Among the Weeds

23 × 33 cm (9 × 13 in)

Before applying any paint I used masking fluid, which when removed at the end of the painting suggested small white flowers. The colours used were French Ultramarine and Yellow Ochre, two very strong colours to work with. Here and there I also used some scratching out with a scalpel. A little white gouache was necessary to correct some careless painting.

However, you may find this difficult to achieve. A common objection is that it is difficult to see the subject properly. A possible solution is to engage in a kind of intermittent on/off squinting procedure. It is certainly worth persevering with this technique because it is one way to make your paintings become much more tonally interesting.

If this is too difficult, you could resort to black and white photography to provide you with a reference, or alternatively photocopy or scan colour photographs in black and white. Nevertheless, it is best to rely on your own abilities rather than photographic or electronic devices so that you can learn to see tonal values in the subject for yourself.

ONE-COLOUR WATERCOLOUR

A single colour watercolour might be made as a tonal study for a finished painting, or it could be a painting in its own right.

A one-colour study allows the lights and darks of a proposed painting to be planned without any

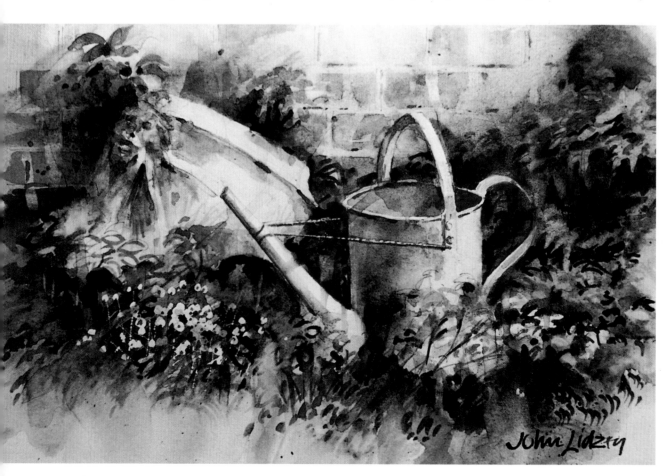

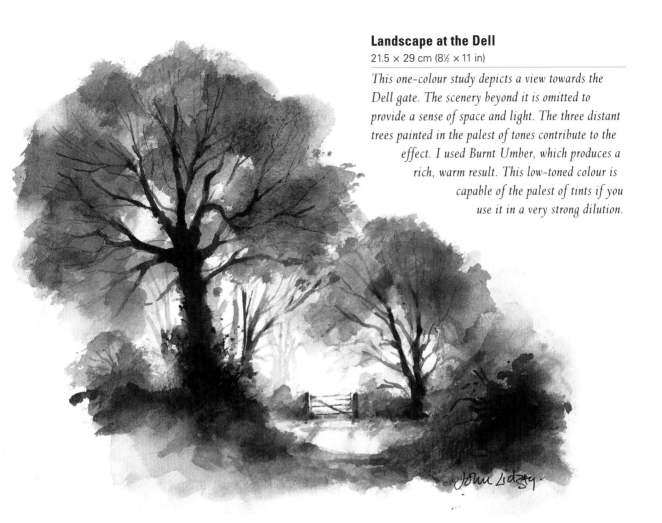

Landscape at the Dell

21.5 × 29 cm (8½ × 11 in)

This one-colour study depicts a view towards the Dell gate. The scenery beyond it is omitted to provide a sense of space and light. The three distant trees painted in the palest of tones contribute to the effect. I used Burnt Umber, which produces a rich, warm result. This low-toned colour is capable of the palest of tints if you use it in a very strong dilution.

other distractions. In a landscape, for example, it is possible to concentrate on tone as a means of creating aerial perspective independent of colour. Distant features painted in a pale tone will recede, while those brushed in with stronger values will advance. Thus, a foreground tree painted dark will look close, and a distant mountain painted in light tone will look far off. If tones are carefully used they can create a misty quality in a landscape or even provide a sense of strong light. When painting in full colour it is often more difficult to see the effectiveness of tone in this context.

In the one-colour example here, *Landscape at the Dell*, I chose Burnt Umber as a suitable colour although there are other colours that would do just as well: Indian Red, Indigo, Davy's Grey or any low-toned neutral mixed from other colours. Many Rembrandt landscapes are drawn in pen with bistre washes. These inspirational works show what can be achieved with limited colour.

Apparently drawn for their own sake rather than in preparation for other work, the drawings are well worth looking at. Bistre was a transparent water-soluble brownish-yellow pigment made by boiling the soot of wood.

Try experimenting yourself with Burnt Umber or some of the other colours I have suggested. Either repaint versions of your earlier paintings or work on a fresh subject. Persevere and you may find that an atmospheric and controlled watercolour will result.

Modern printing technology makes full-colour imagery commonplace now. We see coloured pictures daily on television, in the cinema, on posters, in books, magazines and the Internet. Colour is so ubiquitous that now it can somehow seem cheap. On this basis, painting in restrained colour might be identified with subtlety and profundity, giving satisfaction to painter and viewer alike.

12 BROWN STUDIES

Answered by:
Tom Robb

How can I use the variety of browns in my paintbox to give rich, warm effects?

Brown – it is a word sounding round and rich, with nuances that bring to mind dark shadows in lamplit rooms, forbidding skies on the edge of a storm, and the soft whisper of skeleton leaves as the landscape turns from autumn to winter.

It is a colour for serious images. To be in a brown study is to be deep in thought; brown bread, sugar, rice, etc, are symbolic of natural goodness instead of the refined, bright whiteness once demanded by consumers; and it has even been immortalized in jazz by the sad story of an errant lover who 'turns my brown eyes blue' – a clever use of colour imagery to tell a story in just five words.

The history of brown pigment is sober and serious, too, with none of the excitement of the perpetual search for ever more vibrant purples, reds and greens. Around 15,000BC the red and yellow palette of prehistoric peoples was enlarged by the use of browns and blacks, made from manganese oxide earths, and white, made from calcite. The Lascaux cave paintings date from this

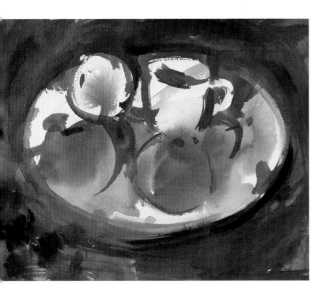

▲ Still Life
30.5 × 39 cm (12 × 15½ in)

Rediscovering how browns make the perfect background, this wet-on-wet still life is a swirl of shape and colour set off by the rich mixture of Burnt Umber and Indian Red, given substance by adding Lamp Black to the washes around the plate and in the corner. Splashing on brown gives a confident, reassuring feeling to any composition — look at some of the best watercolours from the past and see how rich, strong colours such as brown bring power and strength to the merest sketch.

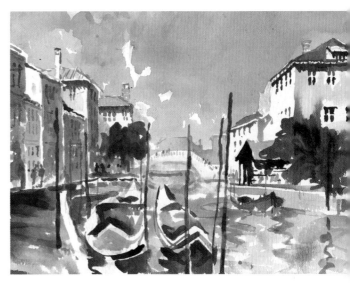

▲ Rio di San Travaso, Venice
30.5 × 39 cm (12 × 15½ in)

Loose and full of movement, this Venetian canal scene shows how different browns can be when used with splash and panache. The sky, darker blue than in The Square in Siena *on page 64-5, and the yellow-rippled waters of the canal are equally impressionistic. Only the gondola poles add a touch of strong colour, but the effect is undoubtedly more full of life. In this watercolour I had a bit more fun with colours, as brown was used exclusively for the buildings and boats, and blue for the sky and water.*

period, and with more than a thousand paintings and drawings show how imaginative this relatively restricted palette can be.

The yellow ochres are sourced from goethite, a yellow iron oxide, which was mixed with a small

◄ Garden Shed Still Life, 1955 (John Minton)
28 × 38 cm (11 × 15 in)

A wonderfully fluent example by one of the finest draughtsmen of our time. John Minton had a particular love of drawing with pen and ink, capturing all the essential ingredients of his subject in an assured and descriptive line, before adding watercolour wash. Here he used Viridian and Indian Red to make a palette of soft browns. Only a few black washes emphasize the shadows of pots, boxes and the corners of this ordinary shed. This painting also shows how a mundane subject can be turned into a vibrant work.

amount of manganese oxide to create siennas and umbers; too much manganese and the palette becomes black. These earths are all found naturally in southern Europe.

In the ensuing millennia, we lose trace of brown pigments, but we do know that up to the eighteenth century sienna and umber earths were still, as they remain, a basic pigment for all artists in every medium, while sepia was being manufactured from cuttlefish ink bound with gum arabic, and even counterfeited by using chimney soot! A rather grisly pigment was known as caput mortuum because its violet-brown colour was supposed to have been made from the mummies of ancient Egypt. Madder plants made a rich brown, but it was seldom reliable or lightfast. Chemistry and science began to transform the range; today classical names remain, but very few of the original pigment sources are the same.

RICH WARMTH

Yellow Ochre

Raw Sienna

Burnt Sienna

Vandyke Brown

Sepia

Brown Madder

Raw Umber

Burnt Umber

RICH WARMTH

These eight browns comprise a selection of colours that together give a substantial range.

Yellow Ochre The first and foremost earth colour, this soft golden brown is absolutely essential for any kind of painting, and irreplaceable. Yellow Ochre is not only a beautiful colour in its own right, it makes the perfect choice for an overall first wash to warm up an entire painting.

Raw Sienna True Raw Sienna is transparent, absolutely lightfast and smooth, even though it has a granular clay base. Unfortunately many lesser manufacturers use a dark yellow ochre, so to be sure of getting raw sienna pigment, ask to see the manufacturer's leaflet when buying from an art shop, and check the pigment information given on it.

Burnt Sienna Take care here, too, as many mixtures are not the pure pigment and will separate out when used as a wash. In washes and in mixes Burnt Sienna tends towards orange rather than brown. It is a rich, smooth colour, even in the thinnest wash. All the 'burnt' colours – sienna, umber, etc – are made by heating the minerals to create a variety of deeper tones.

Vandyke Brown This name, which comes from a colour used by the portrait artist Van Dyck, was once made from coal or wood, but that faded to a dull, cold greyish brown after a comparatively short time. Today modern synthetics have replaced the original material and although the name is the same, the actual pigments are often completely different, so you will have to check against the manufacturer's colour charts to confirm you have the shade of brown you want.

Sepia Originally made from cuttlefish or squid ink, Sepia was a favourite when reduced down to form a good, fairly intense drawing ink. Today it is another ancient name with a totally modern synthetic base, so again check the colour charts because some Sepia watercolours or chalks are red rather than brown. Use it in the classical way for drawings and complete sketches.

Brown Madder Another traditional name for a modern mix; like all the madders this was once a vegetable dye, now replaced by mixtures which often contain Alizarin Crimson. Check the number of ingredients given on the manufacturer's leaflet to see how much more you can add before the colour becomes muddy.

The Square in Siena
30.5 × 38 cm (12 × 15 in)

This city scene could not be more different than Rio di San Travaso, Venice on page 63. The great square of Siena reflects the town's strict architecture, and the austere style of the early Italian city-states. In this painting, sienna mixes are the main palette, as appropriate, the warm ochres cooled with blue. They are considerably deepened in the shadows, and paler on the open, deserted early-morning piazza. The sky, too, has the pearly colour of early morning.

MIXED BROWNS

Burnt Umber/Yellow Ochre

Yellow Ochre/Ivory Black

Burnt Umber/Viridian

Yellow Ochre/Indian Red

Burnt Umber/Cadmium Red

Alizarin Crimson/Viridian

Raw Umber True Raw Umber is a lovely earth pigment that has a slight green cast. Transparent, very light and yet still granular, it does not mix easily, but the colour is unique and essential for a wide variety of mixes.

Burnt Umber When roasted, umber becomes at first a soft neutral brown, but when the process is continued it becomes more and more reddish.

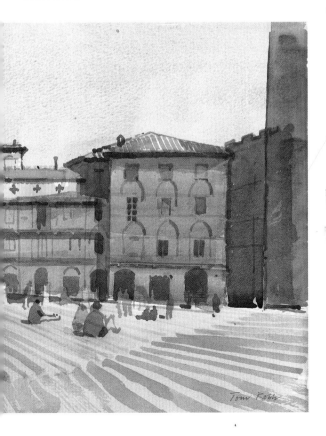

It is the richest of all the earth browns, with depth and lustre perfect for warm shadows, rich velvet fabrics and ripe patches on fruit.

MIXED BROWNS

Although these colours are widely available in manufacturers' ranges, mixing individual browns is easy and effective. This second group is of browns made up by mixing two colours on the palette and they can be individually modulated to create the exact shade you want.

Burnt Umber/Yellow Ochre A perfect mix to create a wide range that allows an intriguing variety of deep red-browns. The more yellow shades bring to mind that first turning of the autumn leaves.

Burnt Umber/Viridian When you need a colder colour, the green here cools down the umber. Use this for winter fields and hedges. As with all colours, do remember that any mixes you make will depend on the precise constituents of the individual pigments and who makes them.

Burnt Umber/Cadmium Red The richest mix, with full velvety texture; try it for heavy textiles or tabletops under bowls of fruit. Warming up brown by carefully adding a red is one of the great pleasures, discovering just the right depth and tone for the subject.

Yellow Ochre/Ivory Black A grey-brown but, lacking the green cast, still warm. This is often used instead of a Lamp Black, for extra colour. Black as an ingredient in mixes is much maligned, yet it can produce beautiful colours. But do try different blacks. Some are cool, some hot, and the change will be significant; look at Lamp Black and Charcoal Black, for example, with Yellow Ochre.

Yellow Ochre/Indian Red Lively and light, for washes on drawings and brighter touches in autumn landscapes. One of the most cheerful browns – use it generously.

Alizarin Crimson/Viridian Not surprisingly, this creates the greenest of all these mixes, so it is a truly cold colour. Use for metals and silver-green winter shrubs. Red and green mixes are the classic source of brown, but the theory depends entirely on the paint pigments. So it is worth trying as many as you can and keeping a record of relative quantities. Start with the greens and add the reds drop by drop.

13 DIRECT APPROACH

How do I decide whether the 'direct' method or the 'wash' method is best for my watercolour painting?

Answered by:
Judi Whitton

If only life were simple and we had a clear set of rules to fall back on when we are painting! The joy of being an artist, however, is that there are no rules. But when you are about to paint a watercolour it is worth giving some thought as to the options available.

The 'direct' approach is the term used when the paint is applied onto the white paper and there is very little overlaying of paint. And then there is the 'wash' method, where there are underlying washes that are left to dry, before one or more applications are laid over the top in such a way that the underlying washes show through.

Of course, there are many other painting methods – pen and wash, for example – but for traditional watercolour painting it is interesting to see how these two broad approaches differ and how they can overlap.

THE 'DIRECT' METHOD

One of the main advantages of the direct method is that it is user-friendly when you are painting outside on a damp day. When using the 'wash' method the underlying wash sometimes takes a while to dry and it becomes impossible to complete the picture.

Another advantage of the direct method is that if some of the white paper is left unpainted this can give sparkle to the finished work. There is nothing like a little rim of unpainted paper around the hair of a backlit subject, together with areas of unpainted paper on a pavement, to give life and sunshine to a painting of a street scene, for instance. In a flower painting a sunlit petal can look quite vibrant if left unpainted and surrounded with a strongly painted area.

Of course, you can also preserve areas of white paper when using the wash method by applying a resist before beginning the painting, but you do not usually achieve the same 'sparkle' as you do when painting directly.

One of the other advantages of the direct method is the opportunity to achieve wonderfully rich dark colours. It is important to make a

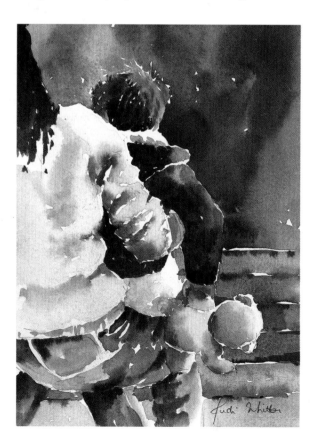

After the Tears
24 × 16.5 cm (9½ × 6½ in)

The direct method used here enabled a strong interlocking design of dark and light areas.

mixture that comprises enough paint and enough water, and apply it to the white paper. The paint should be laid with a single stroke and then left alone for the water to evaporate off and the pigment to settle onto the paper. It is hard to achieve anything as effective if you have a wash underneath. It is worth having a look at John Yardley's paintings to see how a single application of paint in a considered manner can achieve a remarkably rich colour.

Sometimes I hear artists say that they have 'built up' the darks in their work with several layers of paint. It is true that you can achieve a dark colour with overlays of paint, but it is difficult to achieve a rich dark. When overlaying layers each subsequent wash can stir up the washes underneath; the work can begin to look muddy and there is a 'deadness' in the darks.

So, the three main advantages of the 'direct' method are:

1) It is easier to manage when painting outside on a damp day.
2) The unpainted areas can give 'sparkle' and sunshine to a painting.
3) When the paint is applied properly you can achieve excellent rich dark colours.

THE 'WASH' METHOD

Perhaps the wash method is considered to be the most traditional method of watercolour painting. Certainly some of the famous traditional watercolourists such as Peter de Wint (1784–1849) and Francis Towne (1739/40–1816), favoured this method. Quite often their unfinished works are exhibited and give a marvellous insight into the artists' working methods. Washes were laid and allowed to dry and the work was built up in this manner. The number of washes varied. Towards the end of the painting more detail was added.

A few years ago there was an exhibition of Turner's watercolours at the Tate Gallery that included several watercolour sketchbooks in which Turner had been experimenting with his preliminary washes (underpaintings) in preparation for some of his great paintings. For one of his paintings you could see where he had practised his underpainting. He had carefully laid his washes, using Crimson, Cobalt and Naples

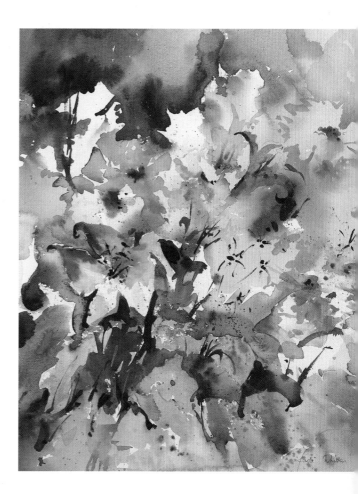

The Orange Lily
48 × 38 cm (19 × 15 in)

This flower painting was painted directly onto the white paper and is an example of the direct method. The small areas of unpainted paper next to the rich dark washes give sparkle to the painting.

Yellow to designate the cool and warm areas. Turner took great care over the preliminary washes. The final success of the painting depended heavily on the execution of the first wash.

The most important consideration, probably, when using the wash method is that if a wash is to be laid on top of another with the minimum risk of stirring up the first wash with the second, then the first wash must be thoroughly dry.

You can, of course, put a wash all over the paper and, while it is still wet, work into it with thicker mixes. This method is really 'wet into wet' and it is not the method of overlaying washes that I am describing here.

Winter Tree at Frampton upon Severn
28 × 20 cm (11 × 8 in)

This simple picture, using the direct method, was painted on a bitterly cold day when it would have been impossible to have used the wash method as the paint would not have dried. Despite its hasty appearance this painting took quite a long time to do. I was with two painting companions and despite our determination not to be the first one to give up we were eventually beaten by the cold and retired to the nearby pub! Although it may appear very unfinished (I do not believe in 'finished' paintings anyway!), I hope it captures the feeling of the bare branches against the building.

Some artists who use the wash method feel that the transparency of the pigments is very important. In one of the trial washes, putting a shadow across a roof as, for example, in my painting *Siena*, the transparency of the shadow mix is important. This is an indeterminate area though, as all watercolour pigments are transparent to some extent, depending on how much water is used in the wash.

Without going too deeply into colour mixing theory and the transparent properties of pigments, it is worth having a little knowledge when using the 'wash' method. Trevor Waugh achieves a remarkable effect of colour and light in his watercolours from a skilled use of this method. However, it is surprising how effective and successful washes of, for example, the earth colours can be, even though they are not known for their transparency.

Another important consideration with the wash method is the choice of watercolour paper.

Some papers are more absorbent than others. An absorbent paper, with less size used in its production, will allow the preliminary wash to soak into the surface and minimize the likelihood of disturbing the early washes. Whatman paper is particularly successful for the wash method. It is worth experimenting with different papers to find one that suits your particular way of applying paint as well as the required effect.

The main advantage of this method is the sense of harmony that can be achieved within a painting when the underlying washes show through the later washes.

Considerations when using the 'wash' method are:
1) Take time to practise the preliminary wash.
2) The first wash must be dry before subsequent washes are applied.
3) Have a little knowledge about the transparency of the pigments you like to use but do not become overwhelmed.
4) Experiment with different watercolour papers.

◀ Siena
21.5 × 29 cm (8½ × 11½ in)

This was painted from a hotel balcony. The underlying wash (using Raw Sienna and Burnt Sienna) can clearly be seen over much of the picture.

▲ Ludlow Castle
7.5 × 17.8 cm (3 × 7in)

This small painting is a good example of the wash method. First I applied a wash all over the paper (using puddles of Raw Sienna, Cobalt Blue and Winsor Lemon). When this was dry I applied second washes for the castle, tree, bushes and foreground. Then, while this was drying, smaller 'calligraphic' marks were added for the branches, grasses, etc. When the paint was finally dry a touch of spatter in the tree was added.

WHICH METHOD SHOULD I USE?
The choice of method is a difficult question. My view is that a good watercolourist should be equally at home with both methods, and choose the appropriate method depending upon the subject, the look you want to achieve in the finished work, and the practical circumstances.

Watercolour is such a difficult medium, though, that it is hard enough mastering any approach and I think most artists would have a preferred method. As a very superficial overall view I feel that an atmospheric subject, such as a misty day or the glow of evening light lends itself more to the 'wash' method. A bright sunny day with cast shadows and a feeling of sunshine may benefit from the 'direct' approach. It is all very much a personal preference. I have seen quite a few demonstrations where the artist painted

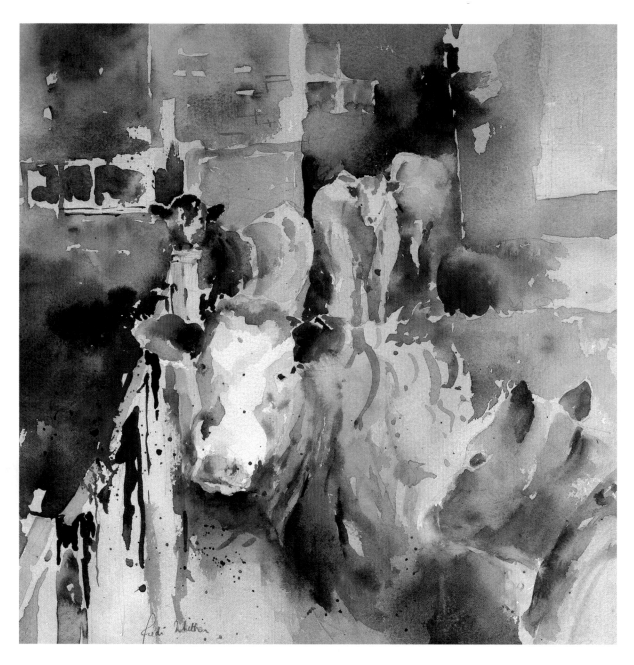

directly for part of the picture and then overlaid washes for other areas. I believe Sir William Russell Flint (1880–1970) would lay his magnificent washes and then, when dry, carefully remove an area for a figure and then paint the figure in directly. James Fletcher Watson often applies a preliminary wash (he calls it his 'soup') just on the foreground. The paintings of John Singer Sargent (1856–1925) sometimes look as though both methods are used within the same watercolour. It can be challenging and rewarding to explore a mixed-method approach.

Cows in the Yard
35.5 × 34 cm (14 × 13½ in)

What a wonderful subject for the wash method! The underlying washes form the relationship between the colours of the cows and the fence and walls of the farmyard. I was anxious to marry up the cows with the surroundings and this method helped to hold the whole composition together.

14 TONE CONTROL

How can I overcome a rather flat effect in my paintings?

Answered by:
Hilary Jackson

Tone and the thoughtful use of shadows play a very important part in creating space and volume. One way to develop your ability in this area is to paint a white still life. This exercise should help you to distinguish subtle changes of tone and colour and give you a better understanding of how to depict volume, which in turn will help you overcome a rather flat effect.

SETTING UP

Find about five plain white jugs, vases, bowls and dishes of varying sizes, some with a plain surface and some fluted or textured. Place them on a white work surface or use a white tablecloth or large sheet of paper. Arrange them in front of a white wall or tape white paper as a backdrop behind the group. Close or open the curtains, set up a screen or use a table lamp or anglepoise light to illuminate the group in an interesting way.

Look carefully at the group for some time before beginning work. Decide where the light is coming from and see how that affects the forms. Notice that a bowl that is illuminated from the left will have a shadow outside and underneath on the right, but that the shadow inside the bowl is on the left, as in my *Tonal Study*.

Observe whether the shadow that falls on the work surface or table bends where it falls on the wall. Recognize that although the vessels are all white, some may have a tinge of blue and others

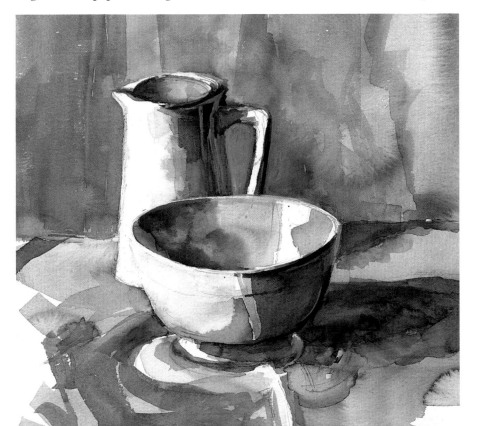

Tonal Study

I used Payne's Grey for this tonal study. The light was coming from the window on my left. Notice how the light falls on the left on the outside and on the right on the inside of each vessel. The light part of one object is contrasted with the dark part of the other and vice versa, producing what is known as counterchange. This effect can be used deliberately or heightened to give a picture interest. Curved forms lit from one side often have a dark shadow on one side, which becomes light again towards the edge.

may be slightly cream or even a little pink. If the tablecloth has been washed with detergent that contains blue whiteners there will be a blue or mauve tint in the shadows.

The shadows on white pottery will not be the sort of grey that you get by mixing black and white, so you will have to work out how to mix them from red, yellow and blue (see the 'Mixing greys' chart opposite). There may well be reflected colours on shiny surfaces and you may even see yourself reflected in some of them. Mix some of those colours and try them out on a suitable strip of watercolour paper before you put them on your painting. You could also make a tonal study with soft pastels or Conté crayons ranging from white through greys to black.

DRAWING

Make several drawings in pencil to decide on composition and the placing on your support. Do not make the drawing very detailed, keep it simple. Remember that negative shapes are just as important as positive shapes; they have to mesh together. Do not attempt any shading at this stage, but make sure you can draw the ellipses accurately and make the various objects the right size in relation to one another (see below).

To decide on angles and to compare sizes, hold up a full-length pencil at arm's length and at right angles to your arm. Turn the pencil in a plane parallel to your face. Compare each angle with vertical or horizontal and transfer it to your drawing. Use the pencil to find out which point is vertically below another or horizontally level with another. Keep the same eye shut each time.

To decide proportions, shut one eye, position the blunt end of your pencil so that it appears to touch one end of the area to be measured and move your thumbnail along the pencil until you see what appears to be the correct length. Compare this measurement with another that you expect to be the same or count how many times it goes into a longer measurement – for example, the width of the neck of the jug goes into the shoulder twice (or one and a half times), or the width of the bowl is the same as the height of the jug.

ANOTHER VIEW

You may find that you have a better view if you move your easel and find a different angle of attack. Try sitting down or standing up and see which gives a better angle and composition.

Use a viewfinder if it will help. Do not accept the first attempt. Crop your drawing with ruled lines or extend it by adding more paper to the sides, whichever improves the image.

Transfer the best drawing onto your support by squaring up and enlarging if necessary.

THE PAINTING

I suggest that you use a restricted palette and recommend two of each primary colour (one 'cool', the other 'warm'). Watercolours tones are lightened with water, but you could also add Titanium White to your selection.

Here is a suitable palette:
- Cadmium Lemon (cool) and Cadmium Yellow (warm)
- Alizarin Crimson (cool) and Cadmium Red (warm)
- Coeruleum (cool) and French Ultramarine (warm)

You will not need black as you can mix very dark colours with this palette. Before you start you could make a reference sheet of grey marks with all the permutations of red, yellow and blue, making a note of the colours you want. For reference you could also add Titanium White.

Now sit or stand back and squint at the objects through half-closed eyes – this filters out a lot of detail and helps you to be more objective about the tones. If it helps, use a tone chart to analyse tones between white and black. Make one or find a paint

Tone chart

Divide a strip of paper into 7 sections. Paint white at one end and black at the other. Mix black with more and more white to make the tones of the grey in between. Use this chart to analyse tones. Look at your still life with one eye shut and the other nearly closed. Hold up the chart so that it appears to touch what you are looking at. Decide which tone is nearest on your chart. You can number sketches from this chart so that you know which tone to use later.

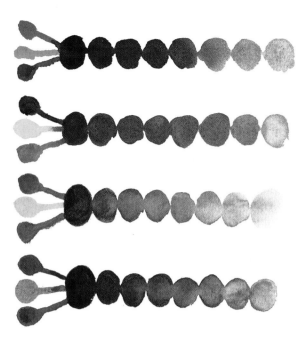

card in greys at the decorators' paint shop.

Decide if there is any true black (fairly unlikely) in the still-life group. Locate the areas of pure white (there will be very few – perhaps shining highlights on glazed pottery); you may wish to mask them out with masking fluid. Decide how light or dark the other areas are. Where are the darkest places – those that receive least light? You could number the tones on your pencil drawing 1 to 5 or 7 (use odd numbers so that you have a middle tone), 1 for the lightest through to 5 or 7 for the darkest tone.

Start to paint the picture in the middle and work outwards so that you can relate surrounding tones to the first tone. Cover the whole picture area with correctly related tones before going on to show detail. Keep everything broad and loose until the very last brushstrokes.

ASSESSMENT

During work move away from your picture to see it from a distance. When you think you are nearly finished, stop and look critically at your work so that you are not tempted to overwork it. Ask yourself these questions and make notes if it helps. Do I like it? Is it finished or over finished? Is it fussy? Is there too much going on? Is it tight? Would it be better if I started again? Does it say what I felt? Is it one picture or several? Is it true to the medium? What went wrong and when? How did I fix it?

Mixing greys

These greys were mixed from a red, a yellow and a blue and lightened in tone by adding more clean water in gradual stages. Try this yourself, using different reds, yellows and blues to find out which work best together. Balancing the correct proportions of each colour gets easier with practice. I used 4 combinations but you could make over 60 permutations and an infinite number of tones.

Top row: *Cadmium Red, Cadmium Yellow and French Ultramarine made dark grey, nearly black. I added more water to make lighter shades of grey. Sedimentary cadmium colours are quite dominant and a lot of blue was needed to neutralize their orange. Being opaque they make a good dark tone and granular lighter shades.*

Second row: *Alizarin Crimson, Cadmium Lemon and Cerulean Blue (Coeruleum) made a dark grey, which I lightened with water. Cerulean Blue is not very strong and Alizarin Crimson is very dominant, so it was difficult to make a dark grey which was not reddish in hue. You can see that the lighter shades have a pink tinge.*

Third row: *Rose Madder Genuine, Aureolin Yellow and Cobalt Blue (three transparent colours) are useful for making delicate greys. Rose Madder tended to be engulfed by the blue so I used quite a lot. Using white pigment to lighten a transparent grey would make it opaque, allowing it to be used in glazes over other colours.*

Fourth row: *Burnt Sienna is transparent, French Ultramarine sedimentary and Yellow Ochre quite opaque. They made an intense dark grey, diluting to a light bluish tone.*

15 THE FREEDOM OF MIXED MEDIA

Answered by:
Anuk Naumann

I would like to add further dimension to my work. How can I combine watercolour with mixed media?

Watercolour need not be wishy washy and pale; you can achieve vibrant colours with an imaginative use of pigment, and exploit the transparency of the medium to get beautiful effects. But what if you want more substance and texture in your work? What if you love the richness and depth of oil paints, but do not feel confident enough to try a new medium, or simply do not want to spend the money needed to buy a whole box of new materials?

In 'Fruits of Experiment' on page 40 I outlined some of the ways in which you can begin to explore the use of watercolour by taking a theme and trying out various techniques. Faced with these problems when looking at my own work I began, almost by accident, to experiment with mixed media, and a whole new world of possibilities opened up. What started with a few tentative additions of tissue paper onto a less than vibrant watercolour to liven it up, led me to try out many different ways to produce the effect I was hoping to achieve.

ADDING A SPARKLE

The joy of mixed media lies in its variety. Almost any number of different materials can be combined to give exciting and unusual effects. Using the same starting point as in 'Fruits of Experiment' – still life – and carrying on from where we left off on page 44, Stages 1 to 3 show the progress of the painting *Luberon Harvest* (opposite). In Stage 1 I applied a loose and varied wash over

Stage 1

Stage 2

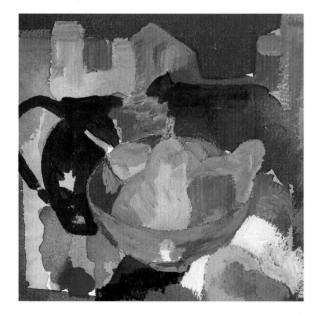

the whole of the paper, not concentrating on any detail, but having in mind where the various elements of the composition would be. Allowing this wash to dry, I began to piece together the picture, using both transparent watercolour, and opaque acrylic. The finishing touches were made with soft pastels. I tend to use a heavyweight 300 gsm (140 lb) rough watercolour paper for my work and find this surface both robust and exciting in texture. Because of the roughness of the support, the pastel marks fragment in a lovely loose way, adding a sparkle to the piece.

Finished painting: Luberon Harvest
mixed media, 15 × 15 cm (6 × 6 in)

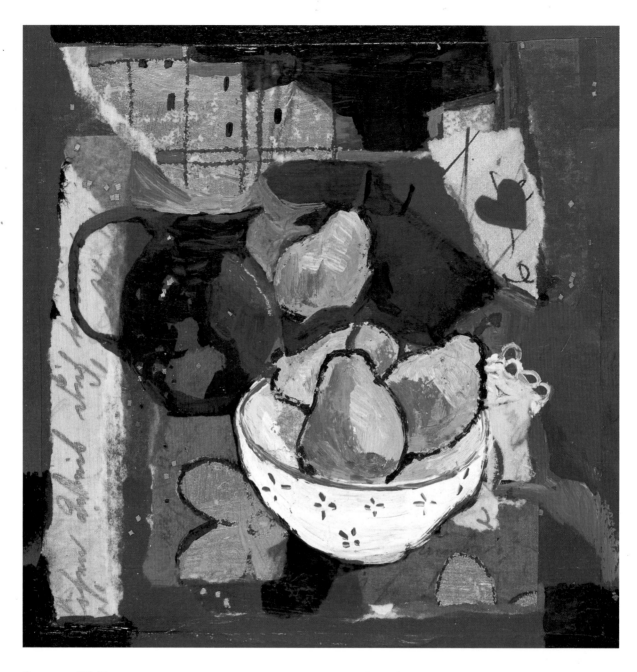

Provençal Table
mixed media, 12.5 × 12.5 cm (5 × 5 in)

Many combinations of different water-based painting techniques can be used with varying effects. Try the vivid, luscious colours of water-based inks together with watercolour and acrylic or gouache; use wax crayons or candles as resists to repel the watercolour in certain areas. Even the felt-tip pen, considered by some to be just for use by children, can add an interesting final touch to a mixed-media painting. I often make use of the various gold and silver pens that are produced to put richness into a composition.

COLLAGE
Another dimension altogether can be achieved in your painting when you try your hand at the exciting medium of collage. A freedom and looseness is introduced to the work simply because it is very hard to tear paper in a completely controlled way. I let the torn shapes guide me into a painting, taking me on an

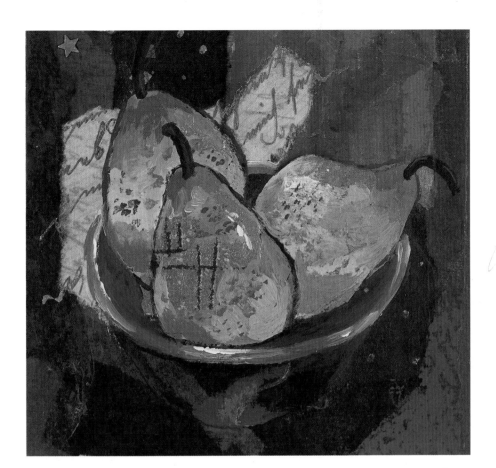

Golden Pears
mixed media,
12.5 × 12.5 cm (5 × 5 in)

unknown journey of discovery. Suddenly all is fluid, nothing proscribed. The excitement of laying torn pieces down on the support, discovering what the resulting patterns and shapes suggest and composing the painting as you go along, with no idea of how the final painting will look, can be stimulating and fun.

In *Provençal Table* (opposite) I began with a heavyweight terracotta coloured paper, which dictated the mood of the picture before I applied any paint. I often use coloured supports for this reason, and allow some of the paper to show through in the finished piece. Using no drawn lines, I began by applying torn pieces of paper, using a variety of art papers and tissues, and even some of my favourite wrapping paper.

To work with collage necessitates a magpie mentality. I collect any interesting papers I can find, filing them in a specially made plan chest in individual colours, so that they are at hand when I start to work.

Once the first layers of papers were stuck down using an acrylic matt medium, and allowed to dry, I began to define the pears and jug with acrylic paint. A final sprinkling of glitter, and the painting was complete.

A word of warning here: once collage is applied with acrylic medium, the nature of the material is such that a waterproof barrier is created, so to apply watercolour over this will not be possible. If you want to create a mixed-media painting, using watercolour and collage, you should always finish all parts of the watercolour sections of the painting first, before any paper is applied. This does not apply to acrylic paint, of course, since it is compatible with the medium used as an adhesive, and can be painted at any stage. Acrylic can be watered down considerably, so that it handles like watercolour.

COLOURS AND SHAPES

The use of collage can take you along exciting new paths, with little idea of what the final destination will be. Try to create a painting using the minimum of paint, watercolour or acrylic, and see how the application of chosen pieces of

paper can make you look at colours and shapes in a new way.

In *Golden Pears* on page 77 I began as before with a coloured card, this time a deep blue. The card colour led me to selecting blues and harmonizing purples, which I layered until I was satisfied that the background was complete. A fragment of wrapping paper with gold lettering helped to

introduce the colour of the pears, which I layered with ochre, gold and yellow papers. The outline round the pears was achieved by leaving some of the blue card visible in order to define the fruit. A minimum of paint marks was used, spattering with a toothbrush to give the spotty surface on the skins of the pears.

PAINTING WITH PAPER

Instead of using larger, random pieces of paper to form the basis of a mixed-media painting, a more deliberate approach can also be used. In *Pears and*

Pears and Blue China
mixed media, 20.5 × 20.5 cm (8 × 8 in)

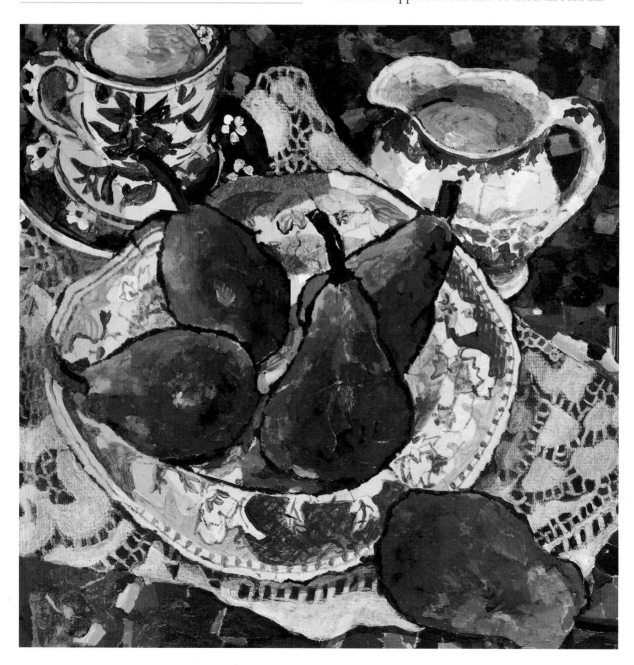

Italian Hill Town
38 × 43 cm (14½ × 17 in)

In the winter these hill towns seem to grow directly out of the rock, but in summer the burgeoning green woodlands act as a cushion to show off the shifting highlights and shadows of the buildings. The green trees are painted in varied mixes of Coeruleum and Lemon Yellow but with much Cadmium Orange added to give them a warm tone. The rocks are Lemon Yellow and sienna mixes, the buildings a lighter version of the same mix.

COLOUR MIXES

When using particular colours a great deal, make up colour mix swatches like these in as many variations as possible, to create a personal reference library.

Blacks and Cadmium Yellow One of the most rewarding mixes is seeing yellow and black turn into such a range of subtle and exciting shades. Here Cadmium Yellow is set against three blacks, and near blacks, to show how it will behave. The colour in the top swatch is a very dark browny-black Sepia, and the autumn-leaf browns and golds that are the result could not be more beautiful. The second, in the middle row, is deep Lamp Black, and the green of the resulting mix is the loveliest of soft verdant tones. The third, Cadmium Yellow into Ivory Black, gives a grey-blue edge and cooler mixes in the centre.

French Ultramarine with yellows and an orange These are the brighter mixes of French Ultramarine with yellows and oranges. Top: Lemon Yellow shows its green cast, with turquoise tones as the two colours blend. Middle: a soft wash with Indian Yellow has equally soft grey-greens in the centre. Bottom: with Cadmium Orange there is a range of cool, almost sepia colours.

Blacks and Cadmium Yellow

French Ultramarine with yellows and an orange

17 PAINTING NUDES

How can I loosen up my life painting?

Answered by:
Sally Fisher

It is enough of a challenge to draw the figure accurately with pencil and eraser, never mind going straight in with paint on pristine watercolour paper. So what possesses the artist to enter into such madness? To answer that you have only to look at some of the beautiful paintings by John Singer Sargent, Cézanne, Russell Flint, Tom Coates, Trevor Chamberlain, to name but a few, to be enchanted by the sensitivity of this most fluid of mediums in capturing the human form.

For me the translucency of watercolour gives flesh a delicacy of life that is irresistible, not to mention all those lovely watercolour puddles and

Francoise
five-minute sketch,
38 × 20.5 cm (15 × 8 in)

grainy washes with pigmented edges. To paint the figure successfully in watercolour is one of the most elusive aspirations, but if you persist, let go, splash about, detach yourself from your expectations and enjoy the process, you might surprise yourself!

When I was at art school in the 1970s (when 'watercolour' was a dirty word) there was a fellow student who, in the long hours of life drawing, started to paint the figure in streams of dripping wet colour (probably acrylic, not watercolour). I was mesmerized by the beautiful translucent veils of vivid colour running down the surface. His paintings were very free and definitely on the abstract side, capturing the figure with grace and fluidity. Those beautiful images of flowing colour and free expression stayed with me for 15 years. Then I finally took the plunge myself.

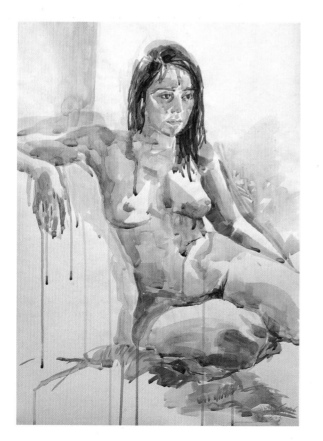

Isobel
38 × 20.5 cm (15 × 8 in)

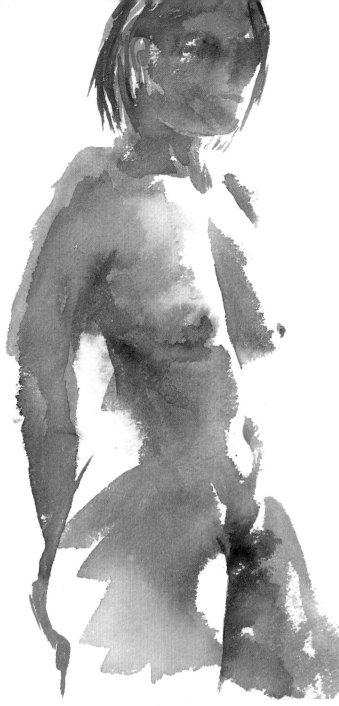

Inge Standing
37 × 23 cm (14½ × 9 in)

Inspired by my initial success I tried again and again to paint the nude in watercolour and nine times out of ten failed. It was as if I had been shown it was possible, but there was a lot more to learn. So I did not give up, but learned a lot as I struggled along the way. Every picture was a surprise, which got me hooked and kept me going. With watercolour you never quite know how it will turn out.

For that first watercolour nude I used 150 gsm (70 lb) cartridge paper, and a 13mm (½ in) flat head synthetic brush, but I have often thought how much nicer it would have looked on watercolour paper. I would recommend using watercolour paper whenever possible; enjoy the effects which, in turn, will encourage you. But if you just feel like trying it out and are inhibited by the expense of watercolour paper, then cartridge paper is fine.

FIGURE DRAWING

Obviously the more practised in life drawing you are, the freer you will be to enjoy the lusciousness of painting, so getting in more drawing practice might be the first step.

A brushful of dripping watercolour frees the hand to move swiftly and loosely, ready to follow the eye and allow creative expression with the unencumbered weightlessness of this fluid medium. If you think of using watercolour in this way as just drawing with paint, you will feel more confident and at ease, and able to concentrate on the drawing.

PAINT

Whether you squeeze colour from tubes on to a palette or saucer, or work from a paintbox your paint and colour range should be immediately accessible. I use an old saucer with a range of hardened watercolour squidges around the edge, just waiting for a brushful of water to activate the colours into running streams of pigment. The advantage of the saucer effect is that as the colours run they merge into interesting colours that the brush is then free to pick up and use, presenting an interesting range of fleshy hues.

For this kind of painting approach it is 'the wetter the better'. By keeping the brush very, very wet you will have complete ease of movement

For the first watercolour nude I did I went straight in with brush and paint with an abstract approach in mind. It took me by surprise in that it worked – drips and all – and, although it did not turn out to be abstract, the freedom of using a brush to draw with, rather than a pencil, was a liberating experience.

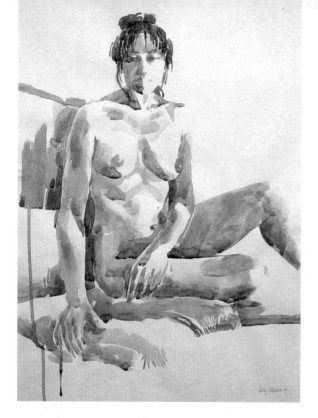

Isobel with her Hair Up
37 × 23 cm (14½ × 39 in)

over the surface of the paper. The more watery the paint the more easily the drawing of the figure can be manoeuvred. Any areas that need adjustment can be simply painted over, leaving the correction visible, which gives drawings a narrative and sense of movement. Working this wet sometimes results in interesting pools and drips that I quite like, although some people do not. If you do not like drips, try working flat at a table or on your lap.

Try doing some really fast watercolour studies – two or five-minute poses – keeping the brush moving, dipping into colour on your palette or using the 'saucer effect'. This will give you confidence as well as free you up.

One useful technique (for the terrified!) is to start off drawing the figure with just clear water or the faintest tint of a neutral tone, then build up, as I did with *Jenny*. This not only familiarizes you with the pose, but also frees up the hand, as you are drawing only in water or very faint tones. You can then introduce colour and tone into and over the water painting. The colour will then flow into the wet tracks, filling the form of the watery

figure, and you will be able to draw and correct as you go. It is an easier way of controlling the flow of the contours with greater accuracy. You can then build up the figure by overlaying washes, building up tone and colour and form. The highlighted areas of the body can be created by painting only the darker tones surrounding it.

A MORE TRADITIONAL RESULT

If you want to achieve a more traditional, accurate result, allowing for time to mix the correct flesh tones, then you may want to establish the drawing first with the minimal of pencil drawing as a guide, and then add paint, as I did with *Inge Sitting* (opposite). Use water-soluble pencils, which work well with watercolour and come in various tones – the softer the darker – giving quite a dark wash when brushed with water. They are, of course, a lovely medium in their own right.

After you have sketched out the figure you can dampen the areas you wish to paint first with clean water and then gently drift in the correct skin tones, controlling how far the tone spreads by using the heel of the brush to fade out the colour

Jenny
37 × 23 cm
(14½ × 9 in)

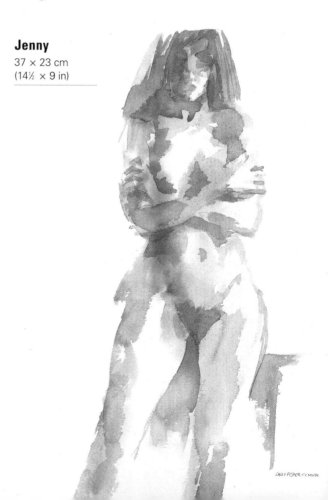

Inge Sitting
35.5 × 25.5 cm (14 × 10 in)

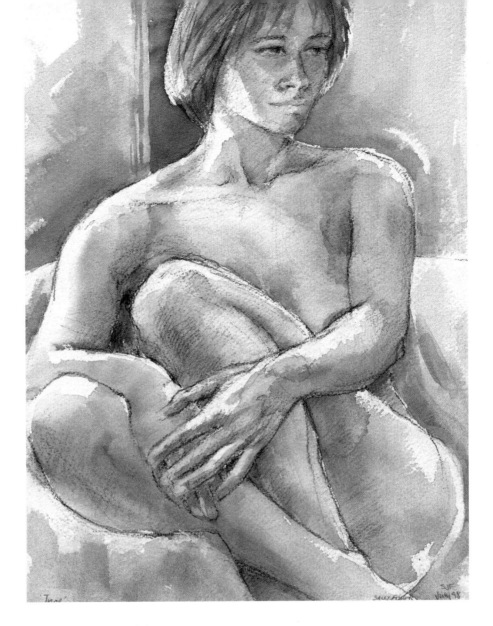

by laying the brush on its side. This is also a useful technique for fading out washes on dry paper. The beauty of watercolour is that you can control and build up tone with wash on wash of varying colours, giving an interesting depth and glow.

Some artists use body colour such as Chinese White to build solidity, which is also useful if you have changes to make and cover. However, it does kill the translucent light. Light, after all, is the quality that watercolour is most famous for capturing. The white paper shining through the colours plays such an important part. It is the same with the watercolour nude – something of the vibrancy is lost when all the paper is covered. Leaving the highlights of the body unpainted, using the darker background around the figure to create the contours, gives a more dynamic lift.

BRUSHES
Use larger brushes rather than small ones to keep your hand free – a Kolinsky sable size 9 is one of my favourites. Other lovely brushes are Winsor & Newton Sceptre Gold One Stroke 13 mm (½in), Pro Arte series 99 size 16 mm(⅝ in) flat head, and Pro Arte series 100 size 14 round head. I like flat heads for their broad-edged strokes, which are good for sharp painting into contours as well as for using lengthwise for thin edges and lines.

So, enjoy the freedom of watercolour next time you go to your life class – do not give up before you have found your way with it. It may even influence the way you paint your landscapes and still lifes. You can never experiment enough in art and you will always learn something, even if it is what does not work!

18 LOST AND FOUND

When should I use 'lost and found' edges in my watercolours?

Answered by:
Judi Whitton

In one of my earlier art classes the teacher often used the term 'lost and found'. I was perplexed by this at first, but as time went on I began to understand what it meant. If, for example, you were painting a Cumbrian landscape and there was a wall running right across the subject then it would be advisable to 'lose and find' the wall so that it was not too eye catching and distracted the viewer from looking 'into' the picture. In this situation it really does seem to look better if the wall is 'broken up' with a gate, or by leaving a gap, or by softening the edges. Another very successful method would be to make part of the wall the same tone as the field so that they merge together to some extent. This is quite a simple aspect of 'lost and found' edges. As you look at the concept more closely you will find that there are other considerations.

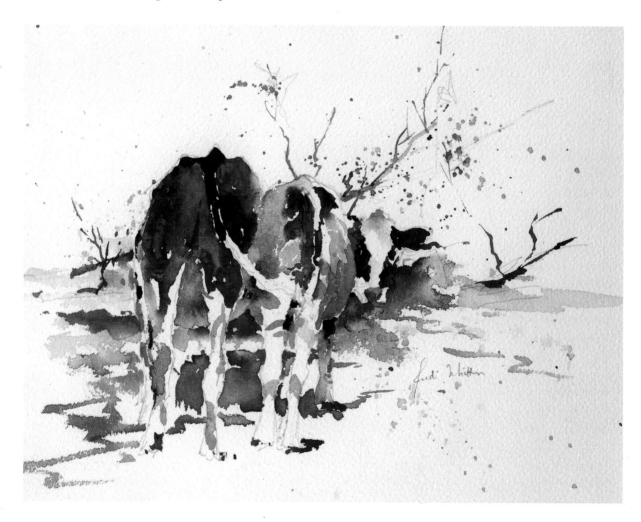

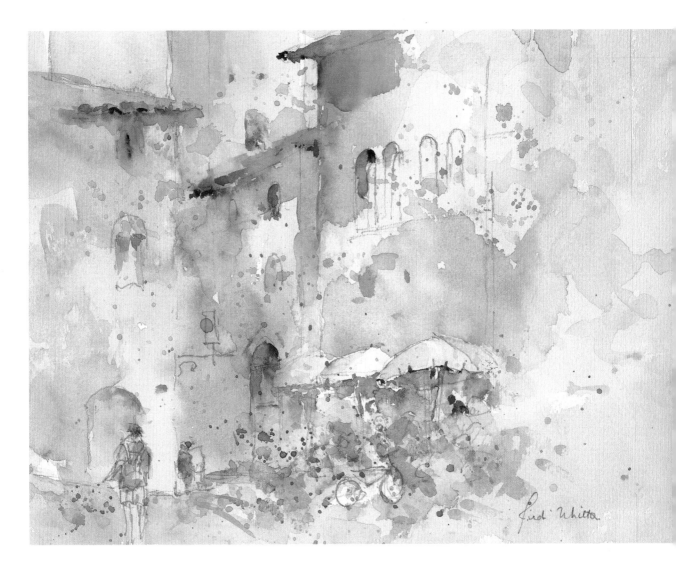

▲ A Corner in San Gimignano

21.5 × 26 cm (8½ × 10¼ in)

This lovely Italian street corner was dominated by several strong vertical walls. To avoid these verticals dividing up the painting I just hinted at the walls by showing them under the eaves and then 'lost' all the edges towards the centre of the painting. It is surprising how little of the walls needs to be delineated for the whole painting to be visually understood.

◄ Two Cows

20.5 × 25.5 cm (8 × 10 in)

This watercolour shows 'lost and found' with hard edges. I did not wish the legs on the cows to become too important in the overall composition, so 'lost' some of the edges in the background by not painting all the background behind the legs.

'LOST AND FOUND' EDGES IN WATERCOLOUR

Watercolour lends itself to soft edges. In a competent watercolour painting very often there is a good balance between hard and soft edges. The painter knows that the viewer's attention will be caught by the hard edges, particularly if there is a strong tonal difference between the two. Too many hard edges and the work looks 'jumpy' and too 'cut out'. Too many soft edges and the work appears to be woolly and indistinct.

'LOST AND FOUND' WITH HARD EDGES

In *Two Cows* (left) I tried to direct the viewer to the areas I thought most interesting by forward planning. I particularly liked the shape of the rear of the cow on the left and the ear of the cow on the right. Both were painted in quite a dark tone, leaving a strong edge against the unpainted background.

Olive Trees in Renoir's Garden
21.5 × 26 cm (8½ × 10¼ in)

Here the edges were 'lost' by softening them and allowing adjacent areas to bleed together. The olive trees were worked up by painting parts of the foliage and parts of the trunk and branches together and going backwards and forwards to develop the required effect. Water was splashed onto the work from time to time and I continuously juggled the hard and soft edges while studying the subject.

The legs of the cows were treated in a different way. I was anxious not to draw too much attention to them and handled the grass in such a way that the legs were 'lost and found' with the background. Sometimes it is quite difficult not to put everything in. For some reason it would have been easier to paint the legs on the cows in one go. It is much more difficult to paint parts of the legs and leave other parts not delineated. In this example I hardly painted the legs at all, but showed them by painting the grass around them.

During the years I have been teaching watercolour painting some of the most difficult lessons have been concerned with this idea of not painting everything. As you progress, however, you will become increasingly adept at distilling the scene and choosing what to leave out and what to put in. This is a personal decision, and it will enable you to develop your paintings. Then you will move onto the area of 'implication' – in other words, how to 'imply' something in the work without stating it obviously. As soon as you grasp this idea your work will become more interesting. Very often some aspect of 'lost and found' is involved in this development.

ARCHITECTURAL SUBJECTS

In *A Corner in San Gimignano* on page 89 I was confronted with a lovely Italian street corner

Renoir's Garden

21.5 × 26 cm (8 × 10¼ in)

The edge of the palm tree was 'lost' in places as it was softened into the roof and walls of the building. The window panes were also encouraged to bleed into the walls of the house.

dominated by several strong vertical walls, which could have been a disaster.

I handled the tall tower at the back by keeping it very low key and keeping the tone very light. To avoid the painting being divided up by the strong verticals I just hinted at the walls by showing them under the eaves and then losing them completely towards the centre of the painting. It is surprising how little of the walls I needed to show. With an architectural subject such as this it is very valuable to use soft edges to hold the picture together.

In these two examples – lost and found edges with hard edges, and lost and found edges in an architectural subject – it is quite challenging for the artist to sort out how to make it work. It is probably a bit more straightforward to explore the concept using soft edges with a natural subject such as a tree.

'LOST AND FOUND' WITH SOFT EDGES

In *Olive Trees in Renoir's Garden* (opposite) I was fascinated by the wonderful old olive trees and the hillside town beyond. I put quite a bit of effort into the trees; building them up, losing edges, implying foliage and trunks. I also spent an equal amount of time deciding whether I needed to do more to the hillside town. In the end I left it alone!

The approach I use is to work on the foliage, branches and trunk together. After a pencil drawing I begin by splashing a little water onto the dry paper and then work a little foliage into this.

Fondamenta Bonlini Tues 3/4/01 5pm frozen

Venice

25.5 × 33 cm (10 × 13 in)

These familiar and much-loved views of this beautiful city are complex to paint. There are a great many edges in sight and therefore many decisions to be made about which to 'lose' and which to 'find'.

Then I begin some work on the trunk of the olive tree, softening it into the damp foliage in places. I work backwards and forwards between the different areas, strengthening, softening and always studying the subject to extract the 'feel' of it. Gradually the picture develops. While I am working I constantly ask myself whether what I am doing is necessary for the overall plan. So many brushstrokes are unnecessary! I am always juggling with hard and soft edges.

HARD EDGE OR SOFT EDGE?

Deciding when to use a hard edge and when to use a soft edge is a big question! Watercolourists generally run together areas of similar tone. For example, if a tree overhangs the roof of a house and the foliage and roof tiles are of a similar tone then they would let the two areas bleed together.

Renoir's Garden on page 91 shows a palm tree in front of Renoir's house. Palm trees against the sky can have a very 'cut out' look. Here, luckily, the palm tree was partially in front of the building and as the tones were similar in places it was helpful to run the foliage and building together.

In this painting there are several areas where hard and soft edges are used. In the windows some of the panes are softened into the walls of the house. If you are painting like this it is quite a struggle to keep the washes wet and you have to

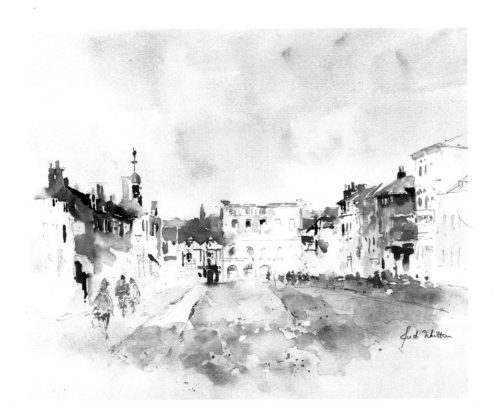

be fairly hasty to begin work on the windows as soon as you have painted the walls. I usually paint the walls and leave the window areas unpainted so that I can keep some of the window panes with a hard edge and run others into the wet walls.

Another reason to choose between a hard and soft edge is 'importance'. If, for example, there is a large row of background trees in your subject that is not the main part of the picture, then softening the edges of the trees so that they merge together is advantageous. The eye will not be drawn to them so readily. This is still the case if the trees are quite dark in tone. Of course, it is sometimes difficult technically to 'hold onto' large areas such as this and keep the edges wet. There is nothing like practice!

It is surprising how you can master this technique and not panic when the paint begins to dry. One of the secrets is to have ready enough paint and water. If you require quite a dark tone within the area it is important to mix a wash with plenty of paint in sufficient water so that it flows happily onto the paper and there is no tendency to have scratchy brushstrokes.

For the important areas of the painting the viewer will be attracted to hard edges.

Sir William Russell Flint's watercolours show this admirably. In his popular figure paintings he would paint the backgrounds subtly and with many softened edges and then would add the figures afterwards with great detail and crisp lines. Again, it is well worth looking at John Singer Sargent's work. He was more likely to incorporate the figure into the background but drew our attention to the areas of interest using the techniques described.

During a recent painting trip to Venice, I had to make decisions about which edges to keep and which to 'lose' when tackling the fabulous canal subjects, as in the painting *Venice* (left). (The comment 'frozen', pencilled in at the bottom, reminded me of how cold it was sitting on the steps by the water!) Complex subjects can look very fussy and overworked if all the edges are crisp, while the sense of the place can still be well represented even when many edges are lost, as in the painting of *Farnham* (above).

As artists we can choose exactly how we want to express ourselves in our paintings. There are no 'rights' or 'wrongs'. We might have a masterpiece at the end of it, we might not, but we can make our own decisions!

19 FABRICS AND FOLDS

I enjoy costume life studies, but I find the fabrics difficult to depict. Can you help me to improve?

Answered by:
Paul Riley

It was usually a Friday and invariably a cold, damp afternoon that found me in a group of freezing art students, slaving over a drawing of a costume life model. In those days it was quite usual for one of the students to pose for the benefit of the others. I remember one girl who used to wear a complicated embroidered silk Victorian costume with a ruff neck. As the afternoon wore on we would intensely observe and draw every detail. I must have drawn and painted that particular outfit dozens of times. However, it was worth it as I was able to get to grips with all the subtle nuances that involve costume life painting.

I was made aware of all the masters before me who had beautifully rendered complex garments with apparent ease – Velazquez, Rembrandt and Leonardo – who had beautiful clothing to work with and who produced work that could only have come from hard work and research. In fact, when you analyse their preparatory drawings you realize the extent of the research. Leonardo da Vinci, for example, used to compare the folds of dresses with the rhythms and flow of water. These artists handled all of their paintings themselves, although in earlier practice it was common for painters to subdivide tasks among specialists.

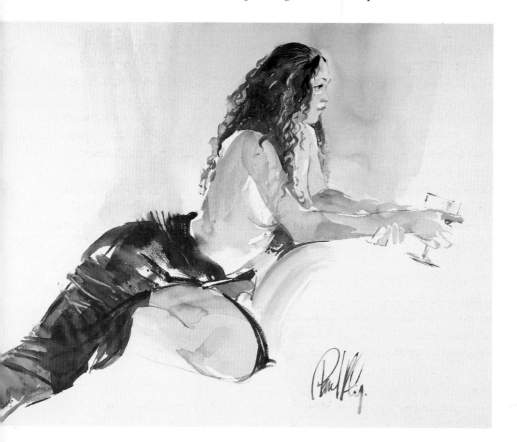

Vin Rouge
76 × 57 cm (22½ × 30 in)

Several techniques were used to obtain the various folds in the sarong. For the broad strokes a hake brush was dipped into two colours: Cadmium Red and Permanent Rose. For the violet overwashing I used both Mauve and Phthalo Blue. For texture I flicked the colour on with a hogs hair brush. Where the paint was dark I was able to use a knife to scrape out near-white highlit folds.

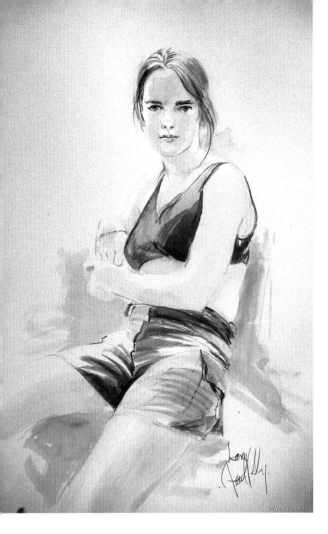

Girl in Brown Shorts
57 × 37 cm (22½ × 14½ in)

Extensive use of the white paper enabled me to express the various fold types as they indicate the underlying form. Hot-pressed paper is ideal for this as you can be very crisp and definite in your linework.

underlying form. This is why, if possible, I like to drape the model to emphasize this. How I long for the days when classical style costuming was dominant, enabling painters like Lord Leighton to indicate every nuance of the figure's form.

FIENDISH FOLDS
A good way to get to grips with folds is to obtain two or three varieties of material, say nylon, rayon and Dralon, for economy, or cotton, silk and velvet, then hang them from a nail so that a good third of their length crumples on the floor, and sketch the folds.

You will notice that the finer fabrics have small, tighter folds, whereas the heavier materials are more open and loose. The next thing to notice is the way in which the different fabrics show the light. In watercolour, indicating folds is a tricky business. I have found that using the largest brush possible with the finest tip is ideal. The reason for this is that as a fold increases in volume you can work the brush from tip to body in one continuous movement. The other technique is to use the brush in a sideways stroke with the paint on the tip only, so that you get a tonal variety in the depth of the fold.

Another variation on this theme is to put two colours on the brush. For example, if it is a red garment I will put a blue red, say Permanent Rose, on the body of the brush with a tip dipped into Cadmium Red. With the sideways stroke the high point in the fold will be a yellower red than the shadow depth, which will be bluer. I normally leave the highlight of a fold as white paper. When it has all dried I can then tint this highlight in a pale colour to suit.

TELLING TEXTURES
Having got to grips with the folds, the next consideration is textures and patterns. As regards

Thus, for example, a separate painter would render the folds of the costume, another would paint the jewellery. This was the way many artists served their apprenticeship.

UNDERLYING STRUCTURE
The biggest trap many painters fall into when depicting clothing on a figure is making it look as though the garments are painted onto the skin. Hats, for example, sit over and around the head and are therefore bigger than the skull, sleeves go round the wrist and hang to indicate a clear opening for the arm.

It is necessary, therefore, to have some understanding of the underlying anatomy that supports the garments. A fair amount of life-drawing practice is invaluable to help you understand what happens underneath, whatever is worn on top. This understanding is especially important when the clothing is lightweight. The material will touch on features such as knees, hips, elbows, shoulders, thereby indicating the

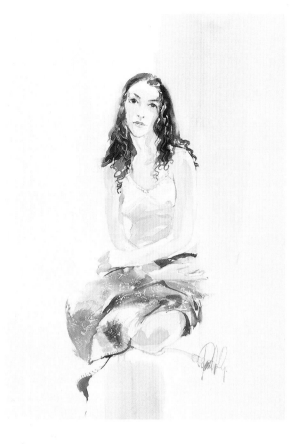

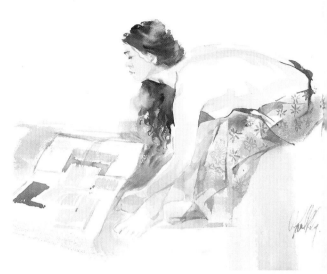

Vanessa Seated
76 × 57 cm (30 × 22½ in)

White clothing can be particularly deceptive, even more so when slightly 'see through'. The colours need to alternate between the delicate warm flesh and the cool violet greys. In this instance I used all staining colours — Phthalo Blue, Permanent Rose and Lemon Yellow. The white decoration on the sarong was a bit of blatant cheating — white paint!

Reading the Paper
76 × 57 cm (22½ × 30 in)

For most of the folds in this painting I used a specialist brush called a Traceur Universal by Isabey. Its unique feature is that it has a central quill of sable hair surrounded by squirrel hair. This enables you to go from a fine line for tight folds to a soft broad stroke where the fold opens out. The decoration of the cloth was also produced using this brush to simply print the design by pressing the length of the hairs onto the paper.

patterns it is essential, particularly with stripes and checks, that the design follows the form of the folds, thence to the form of the model. One small point: I try not to let the pattern become too powerful in tonal contrast as this could detract from the personality of the model.

With regard to textures, there are two ways of tackling them. The most obvious is to do it after the form of the clothing has been painted, which is the standard additive process of applying detail. The slight drawback with this is that it can tend to flatten the form as the detail 'sits' on the surface. The other way is to apply the texture first by

using staining pigments and then, when this is dry, paint the form in transparent colour. This has the effect of incorporating the detail into the form. Texture can be applied in a variety of ways from dry brush work to spattering with a tooth brush (I sometimes use a cut-down hog oil-painter's brush for confined areas), or ragging and stippling (I use a short-haired spotter for this).

Some lace effects can be obtained by first laying a pale grey wash, then picking at the paper with the tip of a pointed scalpel blade; you need to use a 300 gsm (140 lb) or heavier weight paper if you are doing this. Ruched ribbonwork can be done using an appropriate width flat brush or folded paper. Incidentally, if you cannot find a model to sit long enough for you to wrestle with these

problems, much satisfaction can be derived by casually draping the clothing over a chair and working from that. If you want to indulge in further agony, sling in a pair of shoes and grapple with them also! Shoes can be fiendishly difficult, particularly when seen head-on, so it is worth practising painting them in as many angles as possible with them placed on the floor.

COMPOSITIONAL CONUNDRUMS

Costume life covers various types of painting, from three-quarter portrait painting or lightly clad life painting to groups of figures. At the end of the day, as in all painting, the compositional aspects need to be considered. To my way of thinking, in the case of costume life the clothing acts in a support role to offer character, poise and stature to the figure. The culminating focal point is the head of the sitter. I therefore use the lines of folds, creases, etc, to lead the viewer's eye towards this point. Imagine that these lines take you on a journey via incidents from the feet to the knees and through to the hands, a turn of the breast, the line of a collarbone until you reach the head and finally the eyes.

A lot of fun can be had in whiling away a cold winter's evening by dressing up your friend from a rag bag of old or discarded clothes. The more exotic or old-fashioned, the better (Rembrandt was a great fan of this). Try painting each other – this doubles the fun! One of the more bizarre things we used to do in those far-off college days was to dress up Fred, our studio skeleton.

Fold strokes

1. *Using large sable brush with Violet on tip and Cadmium Red in body.*
2. *Using hake for undercolour, picking out lace pattern with point of scalpel when paint is dry. For satin edge use a flat sable.*
3. *As above, using flat brush and water to soften edges.*
4. *Splatter texture using goat hair brush.*
5. *Folds obtained using traceur type brush as described in* Reading the Paper.
6. *White folds obtained by scraping dense paint with rounded knife.*

Various types of brush stroke are needed – some crisp, emphasizing the circularity of the limbs, some dry to indicate speed. Softening with a sponge will create depth and movement.

Dance Studies Ballet Rambert

37 × 57 cm (14½ × 22½ in)

The most significant aspect of costume life painting is in the expression of the underlying figure. In depicting dancers while moving you need to show the clothing as demonstrating the flow of the dancer's form.

20 HUNDREDS OF GREENS

Answered by:
Julie Collins

I'm always having trouble with my greens – they often let down my paintings. Can you help?

Coping with greens is a very common problem for students. Years ago I suffered from a particularly bad dose of green aversion myself, when I would go to tremendous lengths to avoid painting green. Poor greens can let down a beautiful painting in many ways. However, you can get over this, so that you deal with your greens (both in flower and landscape painting) with as much gusto and enthusiasm as for other colours.

Arum Lilies
59 × 78 cm (23¼ × 30¾ in)

HOW MANY GREENS CAN YOU SEE?
Since childhood, green has been my least favourite colour; I used to see it as only one colour. By this I mean that green was green, never mind lime green, turquoise green, bottle green or apple green – the possibilities are endless – but not for me! Thankfully, there was a major turning point around the time I painted *Arum Lilies*. I felt so inspired by these magnificent flowers that my aversion flew out of the window and I began to see greens. On closer inspection there are hundreds of different greens. At the top of page 99 are ten descriptions for green that I have thought of.

For fun you might make a list of as many greens as you can think of and then (here is the test!) mix each one and make a chart of the lot.

USING CHARTS

I have learnt to really enjoy greens in my painting. I achieved this by literally looking for greens and eventually getting excited about them. To help you see the range it is very useful to make your own mixing charts.

The two charts below each show 16 greens mixed from four yellows and four blues. The top chart illustrates darker greens and the one below it lighter ones. Making separate charts for dark, medium and light, for example, will give you even

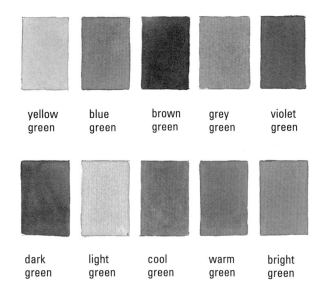

yellow green blue green brown green grey green violet green

dark green light green cool green warm green bright green

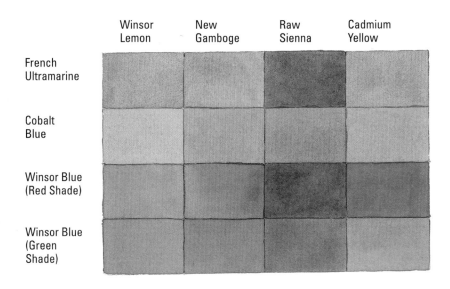

	Winsor Lemon	New Gamboge	Raw Sienna	Cadmium Yellow
French Ultramarine				
Cobalt Blue				
Winsor Blue (Red Shade)				
Winsor Blue (Green Shade)				

Make yourself two different charts: one for dark greens (left) and the other for lighter greens produced by diluting the colour (below). This will help you to mix a wide range of greens and will also help you to consider their tonal qualities. Varying dilutions will produce different tones.

	Winsor Lemon	New Gamboge	Raw Sienna	Cadmium Yellow
French Ultramarine				
Cobalt Blue				
Winsor Blue (Red Shade)				
Winsor Blue (Green Shade)				

HOOKER'S GREEN

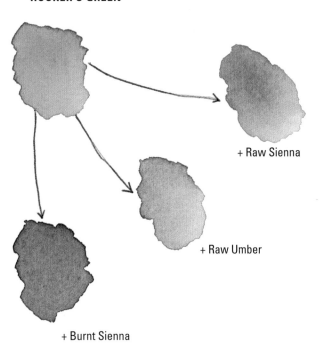

+ Raw Sienna

+ Raw Umber

+ Burnt Sienna

VIRIDIAN

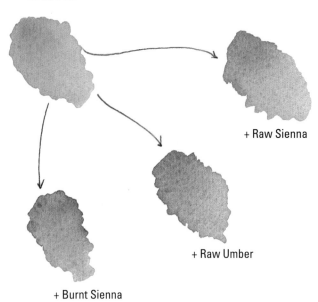

+ Raw Sienna

+ Raw Umber

+ Burnt Sienna

Adding a little brown to a ready-made green can produce colours that more closely match those found in nature, as in these two examples.

Martagon Lily Seed Heads
8 × 5 cm (3 × 2 in)

more greens and will also help you to consider the tonal quality of your colour.

Make these charts on good quality watercolour paper, at least 300 gsm (140 lb) in weight, write down the colours used as I have on page 99 and when they are complete cover them with sticky-backed plastic to protect from water splashes and to make them more robust. Then each time you need to mix particular greens for your painting you can refer to your chart for inspiration. This will help you greatly to learn your way around your watercolour box, with no excuses for settling for 'almost' the right green. Both *Martagon Lily Seed Heads* (above) and *Tulip Tree* (opposite) contain many of the greens shown in these charts.

HOW BRIGHT SHOULD MY GREEN BE?
The potential problem with many of the greens in your palette is that generally they are much brighter than in nature itself. To show you what I mean by this look at the Hooker's Green and Viridian diagrams (left), where each colour has been modified by a brown. The addition of a brown can make a more subtle green, which is very important when painting from nature.

A good example of this is when you are painting a tree in the distance and in your mind's

From these two diagrams you can see that if you paint a tree on the horizon too bright green (bottom), it will 'jump' out at you and you will lose the sense of distance in the composition. Trees in the distance are paler in tone (top), giving a sense of space in the picture.

eye you picture it as being bright, as if you were standing next to it. However, if the tree is almost on the horizon it will be a very dull green or maybe not green at all, but grey or blue. If you paint the tree on the horizon too bright it will jump out at you and then you will lose the distance in your picture (see above).

The greens you mix, both in colour and tone, should also correspond to the other colours in your picture so that there is harmony and unity. In my painting of *Parrot Tulips* on page 103 the greens in the leaves tonally match both the flowers and pot. Also, some of the greens here are very yellow in places, which links in with the yellow in the parrot tulips. Similarly, the greens in *Iris* on page 102 are not too garish, almost brown-green in places,

Tulip Tree
10 × 8 cm (4 × 3 in)

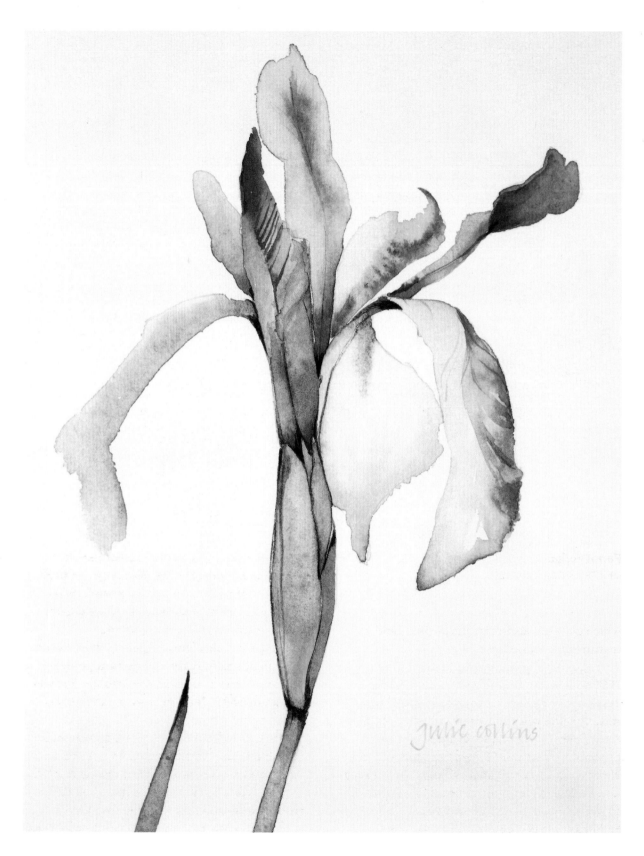

Iris
18 × 13 cm (7 × 5 in)

Parrot Tulips
59 × 78 cm (23¼ × 30¼ in)

which corresponds to the delicate lilacs and texture of this flower.

TESTING

Testing your greens, or any colour you have mixed, before you apply them to your picture, is a crucial step in your work. As a teenager I was proud of my first watercolour box – Winsor & Newton Artists' watercolours bought in a closing down sale in an art shop in Slough. I was pleased to pay only £30 to own a box worth at least £100. So I had very good quality paints, but very little practical knowledge of how to use them. Inevitably this left me extremely frustrated, particularly when I would mix what I thought

was a good dark green only to see it almost disappear as it dried! Some colours dry up to 50 per cent lighter, so testing your green to make sure it is the right green and also to see what it will look like when dry is important.

Finally, do mix plenty of green so that you do not run out halfway through painting your tree as this would mean remixing and testing – and you know how difficult it can be to get 'the correct green' again!

I have included plenty of advice and examples here, but I cannot stress enough that if you want to learn about greens then begin mixing now! The more you mix and practise the more you will be amazed at the subtle differences between one green and another. Then, when you employ these in your painting, your pictures will take on another dimension, particularly if you have been relying on only one or two greens for too long.

21 LIGHTER DARKS

Answered by:
Barry Herniman

Why are darks such a problem? A solid mass of dark colour can look like a black hole instead of becoming an integral part of the painting. How can I overcome this in my work?

Many good watercolours are spoilt by heavy, overworked darks, even though the colour may be correct in value. Often, trying to get the darks 'dark enough' actually causes the problem. More and more paint is mixed up, and more and more layers are put down, in the hope that the resulting passage will be a good strong dark. It is usually very far from the mark.

With watercolour you need only to make your darks a fraction darker than the rest of the picture to make them stand out. Dark has the habit of equalling black, or Payne's Grey, and that is where the equation stops.

I have never used black and stopped using Payne's Grey many years ago because it was affecting everything. I made a conscious decision to remove the grey and mix all my darks from the other colours on my palette. That is not to say

that manufactured greys (or black even) cannot be modified to make good darks; they are just not for me. It comes down to personal preference, so please do not discard your greys on my account. But do try mixing some darks without them and you could surprise yourself. You may never buy another tube of grey again.

MIXING YOUR OWN DARKS

The colour swatches below show my preferred mixed darks. When painting these swatches, I placed a small puddle of each colour on the paper. With the paper at a slight angle I drew the wet paint down to mix together in a third puddle to produce strong and vibrant darks.

My favourite dark is French Ultramarine and Burnt Sienna, sometimes modified with a third colour to give it even more strength.

MY PREFERRED DARKS

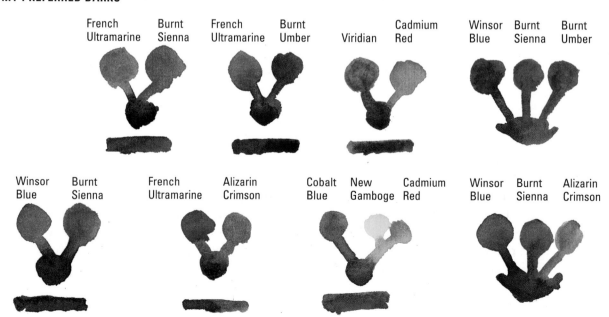

| French Ultramarine | Burnt Sienna | French Ultramarine | Burnt Umber | Viridian | Cadmium Red | Winsor Blue | Burnt Sienna | Burnt Umber |

| Winsor Blue | Burnt Sienna | French Ultramarine | Alizarin Crimson | Cobalt Blue | New Gamboge | Cadmium Red | Winsor Blue | Burnt Sienna | Alizarin Crimson |

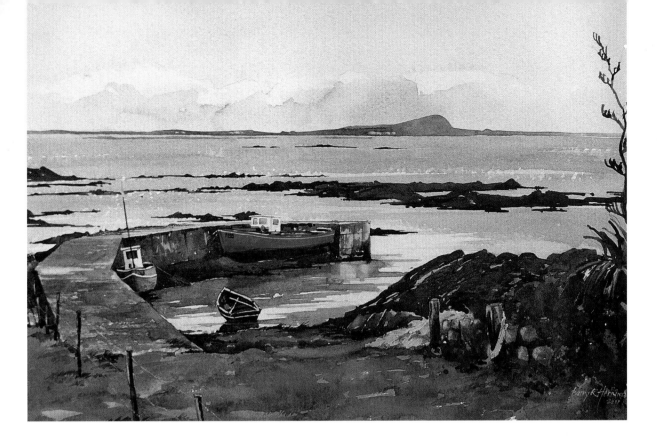

▲ **The Harbour on Clifden Road, Connemara**
35.5 × 53 cm (14 × 21 in)

◄ **The Harbour on Clifden Road** *(detail)*
The darks were painted using the brush tip.

Alizarin Crimson mixed with either Phthalo Green or Viridian also makes rich, velvety darks, A pleasing greyed dark can be produced by using Cobalt Blue and Orange in varying amounts.

LIGHT INTO DARK

Once you start to look into, rather than just at, your darks, you will see just how much light there is in them. Shadows are areas of lesser light. They not only include tonally darker colours but the reflected light from other sources that fill the darks with atmosphere and depth.

The Harbour on Clifden Road, Connemara had a large mound of rocks, a broken wall and assorted fishing nets and tackle in the foreground. This area was quite a tangled mess, so I decided to simplify it and make it an area of dark texture with just the hint of nets and wall. An overall wash was allowed to dry and a stronger wash was dropped over it. While this second application of paint was still wet, I changed certain areas with a much stronger mix of paint which diffused slightly on the wet paper. You can see in the detail that I used the tip of the brush to drop the paint into the still-damp wash.

BEWARE OF OVERMIXING

Mixing up the right colour on the palette can often produce a less than satisfactory dark once down on the paper. I prefer to mix my colours directly on the paper, allowing them to fuse and blend together. The excitement of watercolour comes into its own as the process is not totally controllable, yet the results are often striking.

OVERMIXING

a

b

The two houses on the left demonstrate how the two methods of mixing differ. They were painted using the same colours: French Ultramarine, Burnt Sienna and Alizarin Crimson.

With house (a) I mixed the three colours thoroughly on the palette before putting brush to paper; the result was dark enough, but rather lifeless. House (b) was painted with pure colours straight from the palette, which were allowed to mix directly on the paper. Over-brushing was kept to a minimum and the result is a dark with life and luminosity.

MIXED MEDIA

So far I have dealt only with watercolour, but the same thing goes when it is used with other media.

Evening Light across the Lough, Connemara
35.5 × 53 cm (14 × 21 in)

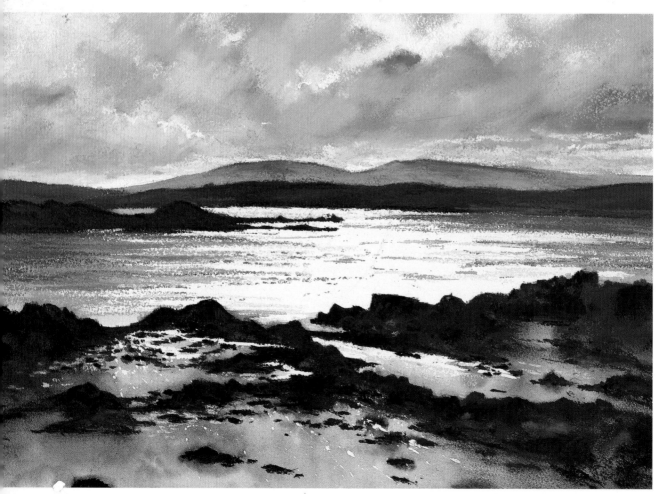

I painted *Evening Light across the Lough, Connemara* (opposite) in watercolour and pastel as I wanted to capture the very strong light on the water. I infused the paper with a strong overall wash, taking care to reserve the whites beforehand. I then took blue, brown and purple pastels and punched in the darks with firm, sharp strokes, laying one colour into and over the next. In places the pastels blended together in the watercolour, while in others the pastel remained totally unmixed. In this way the darks had a slight shimmer to them that captured the reflected light from the water and the sky.

There is a tendency when painting pictures of high contrast to paint the darks black. However, I find that dark areas that are slightly lighter, but infused with colour, seem to look altogether deeper and richer.

DOUBLE GLAZING

Another way of producing darks of strength and luminosity is to use a series of glazes, by putting one transparent layer of paint over another. This way you build up the strength and depth of the dark. The tendency, however, is to overdo the number of glazes, and two applications are usually sufficient, otherwise more and more paint is applied and less and less light from the paper will shine through.

For the glazing demonstration (below) I used two basic mixes: French Ultramarine and Burnt Sienna, and Winsor Blue and Burnt Sienna. I painted these colours right across areas (a) and (b) and left them to dry. Then, using the same mixes, I brushed them across area (b) only. You can see how this second passage is darker, but because the

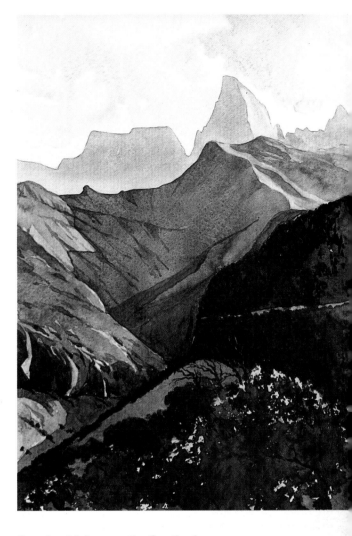

Evening Light over the Sentinel
40.5 × 28 cm (16 × 11 in)

light of the paper is still shining through the washes, the area is alive. Heavy, dense applications of paint will just result in dead, dull darks that will spoil the painting.

Evening Light over the Sentinel was painted using a succession of glazes to build up the strength in the shadows. Very transparent glazes were applied over an underwash on the mid-distant mountains. Some of the pigments granulated and settled into the grain of the paper, adding appropriate texture to the shadow areas. The darks of the foreground hills were built up using strong blues, reds and greens. The colours were applied wet-on-dry and then allowed to fuse together on the paper.

GLAZING

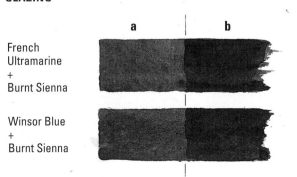

a b

French
Ultramarine
+
Burnt Sienna

Winsor Blue
+
Burnt Sienna

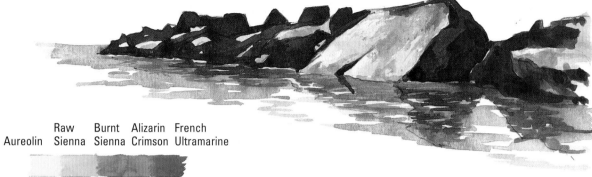

Aureolin | Raw Sienna | Burnt Sienna | Alizarin Crimson | French Ultramarine

a b

▼ **Gloucester Cathedral from Friars Court**
53 × 33 cm (21 × 13 in)

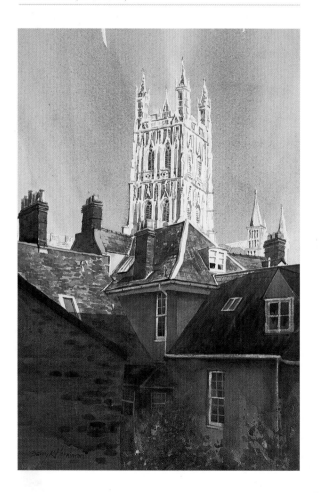

This study of rocks was painted using the five colours shown (left). While the darks were still wet some stronger accents were dropped in to add strength.

Gloucester Cathedral from Friars Court was painted in two stages. First, all the local colours were washed in and allowed to dry thoroughly. Pools of pure colour were then mixed in their individual wells. These I systematically brushed over the entire shadow areas, adding more or less of each colour as I worked through the painting. These washes were laid down quickly so as not to disturb the underlying colours.

The rocks study (above) was done on quite an overcast day, with lots of brooding darks in the rocks. I used five colours to paint the rocks and the shadows: Aureolin, Raw Sienna, Burnt Sienna, Alizarin Crimson and French Ultramarine. I simplified the rocks to emphasize the dark areas. A wash of Aureolin, Raw Sienna and Burnt Sienna was painted over the whole picture and allowed to dry. The darks were then painted in using Burnt Sienna, Alizarin Crimson and French Ultramarine. While they were still wet, I charged certain areas with a stronger mix of these colours to give added depth to the darks.

The colour triangle shows how these paints react when allowed to mix on the paper. All five colours were laid down side by side in the direction of arrow (a). While still wet, the same colours were then brushed over them in the direction of arrow (b). The result shows how all this wet paint produces mixes that are full of life and vigour. Try this using your own colour combinations, but beware of over-brushing — let the colours mix themselves.

22 CRISP AND CLEAR

How do I keep my watercolours looking fresh?

Answered by:
Gerald Green

Preventing watercolour paintings appearing laboured and overworked will maintain their vitality and freshness. Ideally, watercolours should be impressions of the moment, capturing the spirit of a subject and, irrespective of the actual time taken, they should give the impression of not having taken too long to produce. To use a musical analogy, watercolours could be thought of as the soloists compared to oil paintings being the equivalent of the full orchestra. But, like music, watercolours can also be moody and atmospheric, combining gentle, quiet passages with powerful and vigorous accents.

PREPARATORY STEPS

Clean materials are an obvious basic essential in keeping watercolours fresh, so make sure that your colours are freshly laid out in an orderly manner in your palette with any residue of earlier painting sessions removed from your brushes.

As a rule, adopt a painting position that will allow you to work without too much restriction. Standing at an easel or table rather than sitting down will enable you to work freely at arm's length and will facilitate stepping back for an occasional longer view of your work. Holding the brush more towards the end of the handle will

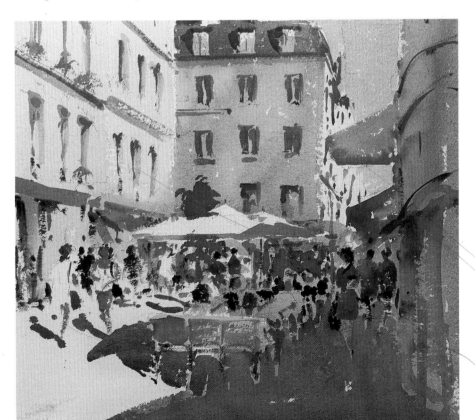

Parisian Side Street
31 × 35 cm (12 × 14 in)

Allowing colours to bleed together on the paper will create more lively surfaces. I painted each of the three building facades with a variety of pure colours using a wet-in-wet approach, varying the amount of water in the washes to suit the lighting condition.

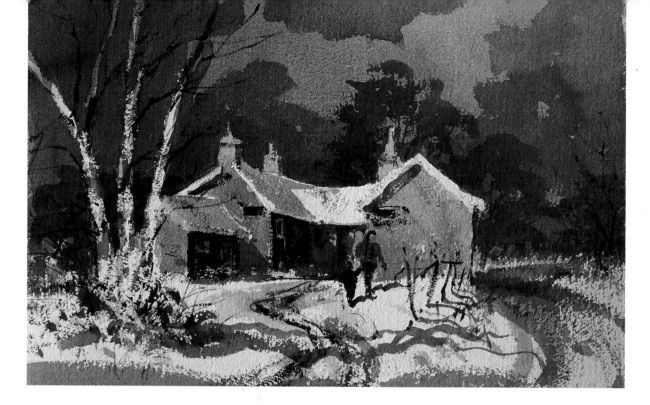

Winter Scene

35 × 50 cm (14 × 20 in)

This painting was produced by the overlaying method. To build up the dark moody sky I laid in three separate washes, beginning with Burnt Sienna, which I also laid over the walls of the buildings, followed by a purple made from French Ultramarine and Light Red, followed by a final wash of Neutral Tint warmed with a touch of Alizarin Crimson. I allowed each under layer to dry completely before applying the next. Touches of these washes were also laid in other parts of the painting.

encourage a less hesitant approach, in preference to holding it nearer the tip, as when writing. Always work with the largest brush that you can. Be bold, and be prepared to take some risks.

The usual method of first sketching out the general features of your subjects should only ever be seen as a guide for the subsequent painting process, and here a loose drawing should suffice. In architectural subjects a layout drawing will need to be accurate, with the various features drawn to obey the rules of perspective etc. However, beware making an over-detailed layout drawing. It can be restrictive and can reduce the painting process to merely filling in the spaces in the drawing. A completed painting can therefore finish up looking rather static and lifeless.

COLOUR APPLICATION

How colour is applied is the main determinant to watercolours retaining their freshness and appeal. To avoid passages of muddy, stale colour, often brought about by too much intermixing, limit your palette mixes, to begin with at least, to a maximum of two colours at a time. Where you want colours to bleed and blend together in a wet-in-wet approach, lay them in against each other on the paper as pure colour. Use the minimum number of brush strokes, rather than applying the paint in the manner of decorating the living room walls. This will allow your colours to run together, settling naturally into the paper, and they will look clean when they have dried. Bear in mind, however, that colours will continue to settle until completely dry, so avoid retouching still-damp passages.

Watercolours are produced as either transparent or more opaque colours, but using only transparent colours will not necessarily prevent muddiness. In the traditional method watercolour washes are applied one on top of the other to build up tone and colour, but too much overlayering will impair the transparency and, as a result, the colours will appear 'dead'. To reduce this effect limit overlayering to a maximum of three washes. It is also important that the under layers are completely dry before overpainting,

Statue, St Germain, Paris

31 × 35 cm (12 × 14 in)

Analogous colour mixes are a means of altering the mood in a painting. Here I used red as the key primary colour, which I played off against more neutral mixes made from the adjacent secondaries of orange and purple. This gave an overall red colour cast to the whole image.

otherwise they will lift during subsequent applications of paint and muddiness will result. You might find it helpful to use a hairdryer to speed up the drying time.

Alternatively, paintings can be produced in a more direct method. Here the aim should be to apply colour passages at the correct tonal value in one application, without the need for further adjustment, painting parts of the image like pieces in a jigsaw puzzle. This requires a bold, confident approach. If you are at all uncertain about the distribution of lights and darks, one or two preliminary roughs to establish the main tonal values will be a helpful guide. When the first colour washes are applied they will always appear to be too dark because you will be judging their value against the white paper. So, until all the white paper is covered, you will not be able to tell whether the tonal values of colour passages are right; some additional overpainting may be needed at the end.

Strong contrasts can also be incorporated to help make paintings appear fresh, and it is important with both methods to preserve the lightest lights as white paper from the outset. Try to avoid using too much masking fluid. When the fluid is removed it has a tendency to give a hard-edged line (unless this is the effect you want), which can appear too dominant in the final stage.

COLOUR CHOICE

Having considered the effects of colour application, let us now consider how the choice of individual colours can be used to invigorate a painting. Since harmonious colour arrangements rarely occur by chance, fresh, lively paintings will have a well-thought-out colour structure.

Accepted colour theory suggests that two complementary colour combinations (opposites on the colour wheel), will appear well balanced. Alternatively, analogous or harmonious mixes (colours chosen from the sides adjacent to a single colour on the colour wheel), will produce a dominant colour key in a painting. For more subtle or muted effects you could use a limited palette of secondary colours. Remember, too, that earth colours will give more natural versions of primary colours.

Touches of pure colour can be introduced to add energy and vigour to a painting to highlight more important elements of the subject, particularly when contrasted with areas of neutral greys. Pearly greys mixed from complementary colours will have more vitality than diluted tube greys or black.

A useful starting point might be to choose just two or three base colours from which most of your mixes can be made. Individual touches of other pure colours can then be included as visual

accents or highlights. Unless done within the context of an overall colour structure, extra touches of pure colour should not be relied upon to brighten up an otherwise lifeless image. The very opposite is usually the best course of action. If your paintings have a tendency to look dull and lifeless, first try reducing the number of colours you are using.

LIFE IN THE SHADE

Shadows are fundamental to achieving the feeling of light in paintings. Retaining life in shadowed and shaded areas will also help to prevent paintings looking dull.

Shadows, though areas of negative light, are very rarely devoid of colour. As a rule they tend to be darker and cooler versions of the colour on which they are cast, with their density dictated by the strength of the lighting. Shaded surfaces will take in reflected light, so usually they will not be as dark as the shadows they cast. When painted too light they will appear weak and unconvincing;

too dark and they will look like solid objects. When the overall tonal values of the lights and darks are balanced, paintings will appear to shine.

UNDERSTATING THE FORMS

Freshness and vitality can also be achieved by allowing elements of a painting to remain understated. Just as it is not necessary to paint every leaf on a tree, the least important elements can be subordinated by merely suggesting their forms, allowing the viewer to fill in the missing parts. This simplification can enhance the feeling of space and distance and will help to draw attention to the main focus in an image.

Finally, being clear at the outset about what you want a painting to say is essential to knowing when it is finished. Try to reduce any tendency to fiddle with areas of paintings in an attempt to neaten them up. If you feel unsure about whether a painting needs more work, put it away for a few days; then look at it again in a mirror and you will see it in a fresh light.

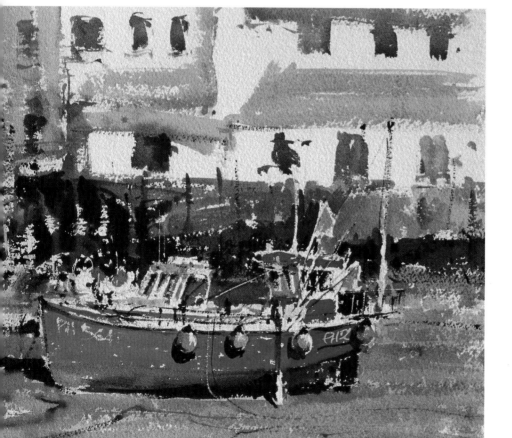

Blue Boat, Polperro
31 × 35 cm (12 × 14 in)

Paintings done in the direct method require a bold approach. Having loosely pencilled in the main forms I began by painting the boat, laying in single applications of colour that I attempted to match to the correct tonal value of the subject. I carefully painted round those areas that were to remain as white paper, and rendered the background buildings with loosely described softer forms to keep them visually in the distance.

Quiet Street, Cirencester

50 × 35 cm (20 × 14 in)

Retaining life in the shadowed areas of paintings is essential. I first washed in several pure colours over the shaded areas of the picture, allowing them to bleed together, covering the buildings, ground shadow and figures. Then I laid a second wash over the shaded faces of the building, cutting around the shapes of the figures and strengthening the ground shadow. Finally, I drew in the darker shapes of the windows and refined the figures themselves.

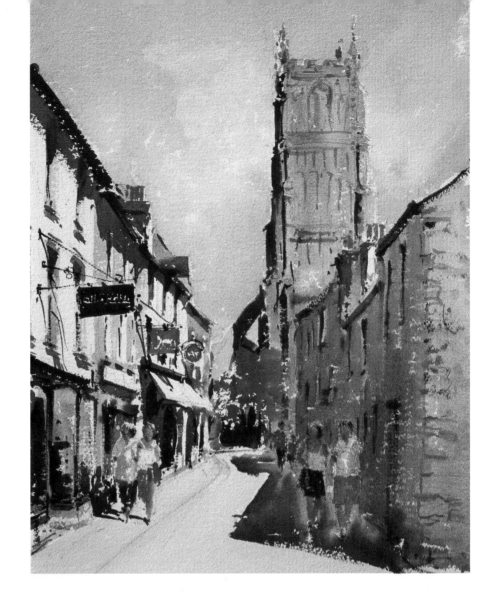

Sewing Room

30 × 42 cm (12 × 16½ in)

Understating the forms helps to give a subject vitality. Even mechanical objects, which at first glance might not be thought to be interesting, can, in this way, be given visual appeal. I used a simple two-colour complementary mix of Burnt Sienna and French Ultramarine together with strong tonal contrasts, which enabled me to give the subject matter additional strength.

23 GOING FOR GOLD

I enjoy using mixed media with watercolour. Can you help me to develop my ideas?

Answered by:
Anuk Naumann

I often find inspiration for paintings by taking a favourite theme. Trying out new media is a useful way of discovering creative possibilities and new ways of working. I begin with sketching and watercolour, using a variety of ways to create marks on the paper, and then I move through the varied possibilities of mixed media and collage. By now different ideas of how to tackle a favourite subject should be starting to emerge.

However, what if you feel that your work is too straightforward and too representational? My students often complain that, although they have no problems in depicting a still life, landscape or, indeed, a portrait in a realistic manner, they find that inspiration leaves them when they try to free up the composition and create a truly individual piece of work. So how do you begin to stretch the theme of your work towards achieving that greater freedom, and allow the subject to take on an exciting appearance that is not necessarily true to life?

STARTING POINTS
Each new stage in the development of a style has a starting point. To challenge and stretch yourself and your work, look at what you have already done and begin to think about areas where a different approach could be used.

In *Perfect Pears* (right) the subject looks straightforward enough: several Williams pears in a red bowl on a lace cloth — all elements in a still life that I have used before. I like mixed media and often use acrylic watered down like watercolour. I had previously painted the composition using acrylic and collage, but in this picture I introduced a new element. Notice that in several areas of the painting I have overlaid text taken from magazines and newspapers. I tried to relate some of the words to the subject and, in fact, use them to help describe what the viewer can see . This use of text takes the painting away from being a realistic representation of the fruit and introduces an element of fun. The lace cloth merges into the written text, creating patterns that move the painting away from realism.

With this use of text, the germ of an idea was sown, and I now began to play around with the two main elements of my composition — text and fruit — this time giving them more of an equal weight within the picture. In *Provençal Pears* (left) I started by tearing sections of newspaper (French, this time, to be in keeping with the subject), and

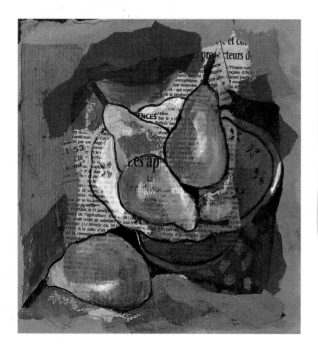

Provençal Pears
mixed media, 23 × 23 cm (9 × 9 in)

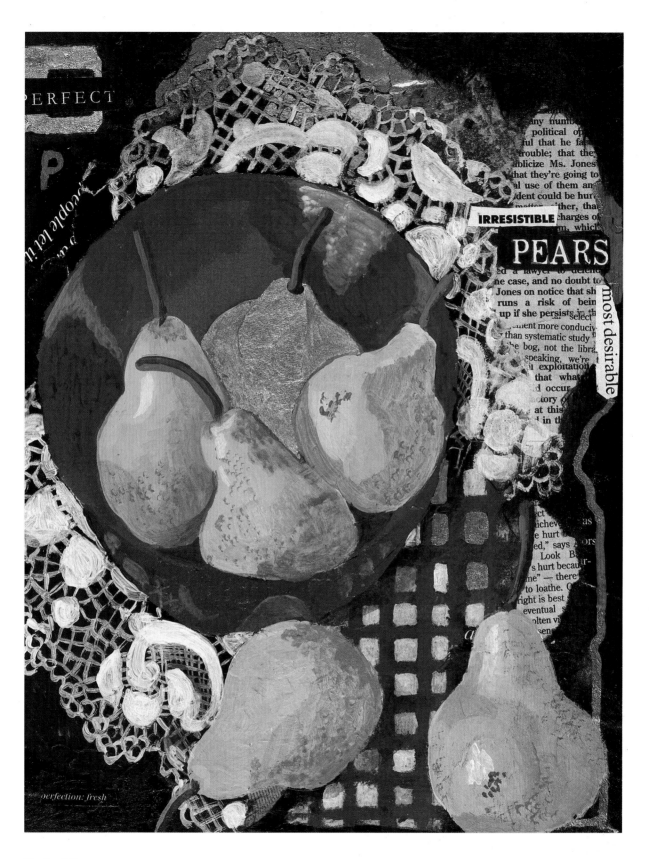

Perfect Pears
mixed media, 30.5 × 20.5 cm (12 × 8 in)

Cornish Table

mixed media,
12.5 × 12.5 cm
(5 × 5 in)

collaged them onto a 600 gsm (300 lb) sheet of coloured paper. I left the edges of the paper uneven to give a more loose effect. Once the collaged paper was dry I drew in the pears and bowl and, using a combination of transparent and opaque layers of acrylic, coloured the fruit. I took care to allow most of the text to show through, and, in fact, to become an important part of the composition. To finish, I overlaid several more pieces of coloured tissue paper and a few strokes of soft pastel. In this painting the pears are recognizable as fruit, but not given as much drawn detail as in *Perfect Pears*. The main emphasis in the composition is the strength of the lines and the patterns created with the collaged papers. In this way the picture becomes a piece of design, not just a faithful still life.

FURTHER DEVELOPMENTS

In *Cornish Table* this idea of design was taken a step further, with flat planes of colour describing the surface onto which the still life was placed. All elements of the painting have been reduced to a minimum, and are deliberately two-dimensional. The pears are recognizable by their shape and the pattern created by cutting one in half, but no attempt has been made to make the fruit lifelike. The patterns created are as important as the individual parts of the composition. The palette was limited to the two primary colours of blue and red, combined with ochres and creams, with white used primarily to set off the fruit. Using both acrylic and collage, the surfaces were kept deliberately flat, with the colour of the support left free to paint in the sky and the left-hand edge.

In all previous examples the still life with pears was not only the theme, but also the main subject of the paintings. Another way to stretch your work and keep your compositions flexible is to put the subject into a different context. With still life this can mean setting your chosen subjects into a landscape, allowing background and foreground to merge naturally without an obvious dividing line.

In *Skye Pears* a couple of pears and a jug stand on a suggested table, whose white cloth is set off against the white houses on the shore. There is a natural divide between sea and shore, shown by the colours used for each, with a connecting element in the blue jug to the front of the painting and the red sail of the boat in the background. The transparent, watery sky gives a sense of distance in the painting.

Skye Pears
mixed media, 30.5 × 30.5 cm (12 × 12 in)

Pears and Cornish Jug
mixed media and gold leaf, 30.5 × 30.5 cm (12 × 12 in)

Pears and Cornish Jug uses the same balance of colur and tone as *Skye Pears*, with this time a more defined chair and table, although the latter is abstracted to a semicircle of white.

MOVING TOWARDS ABSTRACTION
Sometimes a painting can seem more interesting and exciting if the subject is not too obvious, giving the viewer a bit of work to do. In *Golden Pears* (opposite) the scene is a window sill in Provence, and planes of colour have been used in an abstract way to suggest sill and table surfaces. The painting is divided almost in the middle into two halves – the houses outside and the still life within – with two pears breaking one of the horizontal lines and creating a link between background and foreground. The pears are not as dominant as in the previous paintings, but important to the composition – they are also picked out in gold leaf to attract the viewer's attention.

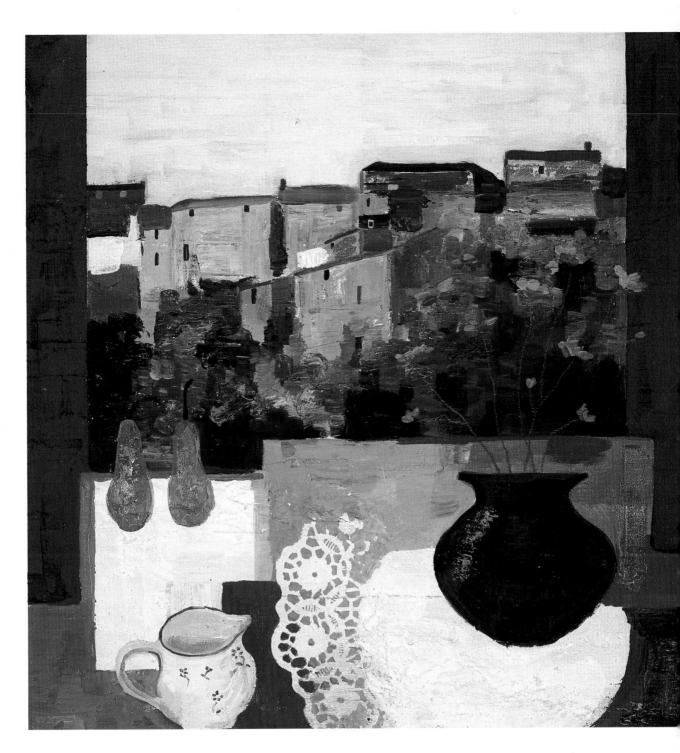

Golden Pears
mixed media and gold leaf, 40.5 × 40.5 cm (16 × 16 in)

I find that each painting I produce contains some element that can be used as a springboard to another piece of work. Keep looking at your work for just such bits of inspiration. They might be very small – for instance, the way you used the watercolour in one section; the shape that was created when you tore a piece of tissue or newsprint; even the words in the newspaper itself!

If you are constantly searching, not just for subjects to paint, but for ideas within your own work, and making annotated sketchbooks, a great many possible paths will open up to you.

24 TIME TO STOP

When is a watercolour finished?

Answered by:
Judi Whitton

Why is it that an unfinished watercolour painting can look so appealing? There seems to be a special quality about a freely drawn sketch that has been partly painted. Somehow we know what the painting is about because the sketch is there and then we have the feeling that the artist just chose to paint the part he felt was vital, and left the rest. Is it because we have an insight into the part in which the artist was really interested; or because what is painted stands out for the simple reason it is surrounded by unpainted paper? Or is it simply that we feel more involved with the painting because we empathize with the fact that the artist stopped at a particular point?

It is this latter idea that is so intriguing and leads us on to ask: 'What is a finished painting?'

▶ Sunlight Through White Petals
38 × 28 cm (15 × 11 in)

As there is little definition, this watercolour could be considered unfinished. I was trying to capture the sense of the light through the petals. Should I have added more detail to the flowers? It was difficult to leave them as they were, but the light touch was in keeping with the rest of the approach and further painting would not have helped to convey the sense of light.

▼ Tomatoes
20.5 × 28 cm (8 × 11 in)

I feel that the quality of this hurried little watercolour is its spontaneity. There are big washes and calligraphic marks. The composition looks natural and there is a sense of colour and light. Should I have worked on it some more?

I had to stop painting this picture at this stage because it began to rain. When I returned to it later I had lost the flow and felt that anything else I added might spoil it. It is an example of work that could be considered unfinished because only part of the drawing has been painted.

THE ARTIST'S CHOICE

It seems clear to me that a finished painting is one that the artist has chosen to finish. I am always interested when people say that my work looks unfinished. What is wonderful about being an artist is that you can decide for yourself when you have said enough in a painting and you can stop. Making this decision, though, is not always easy.

I asked one of my painting friends, who has a much more detailed style than mine, when he thought a watercolour was finished. He replied: 'Usually a long time before you stop painting!' I think this sums up quite a common problem in that sometimes you can overfinish a painting without really intending to. Artists feel a need to put extra information into the work and to fill any gaps as they are getting towards the end of the painting. Very frequently I hear a student say that they preferred their painting at an earlier stage and felt that as they had continued with it they had spoilt it. If only we had a magic wand that would tell us when the picture was at its best and that any further work would detract from the good parts! Experience plays a huge role in helping you to learn to recognize when a picture has reached its best potential.

There are various reasons why a watercolour could be considered to look 'unfinished'. Is a watercolour regarded as unfinished because much of the subject is undefined?

I chose to finish the painting *Sunlight Through White Petals* on page 121 at this stage because I felt that the feeling of light shining through the white petals had been achieved and, although it was tempting to add more detail, especially in the flowers, it would not have added anything.

The watercolour *Tomatoes* on page 120, again, is completed with little detail. Fortunately, the spikes on the main tomato made a lovely feature and this was used to add some definition to the painting. This area, together with the wonderful red colouring of the fruit and the pattern of the tomatoes, made the focus of the painting. In both of these examples there is a loose handling of the paint. All the paper is covered with paint, but there is little detail and the intention is to convey an impression. Was any more detail necessary?

It is sometimes said that a good watercolour comprises big washes with calligraphic marks. Although this is an over-simplified view, it is the extent of the calligraphic marks that determines the degree of definition or detail in a painting.

Clematis on the Fence

35.5 × 50.5 cm (14 × 20 in)

This watercolour took a long time to paint and is quite considered. I painted it in my friend's garden and enjoyed painting the clematis in this loose style, with the drawing being a vital part to the picture and avoiding any botanical representation of the clematis. My friend, however, said she would have preferred a little more information.

Is a watercolour regarded as 'unfinished' when part of the drawing is left unpainted? In the introduction to John Ruskin's famous book *The Elements of Drawing* Lawrence Campbell writes: 'Ruskin in his own drawings had difficulty in quenching his enthusiasm for individual detail. And so we find many of his drawings with brilliantly drawn "facts" isolated in surroundings of generalized unfinished effects ... for the most part it is as though his interest gave out at a certain point, or was exhausted by the intensity of his concentration upon one particular aspect of a building or scene.'

In Ruskin's watercolours we often see beautifully painted areas surrounded by unpainted drawing. I really love these works. Somehow they tell us which part of the picture most interested Ruskin and the unpainted areas support the painted part and give it even more impact. We do not know whether Ruskin felt the paintings were finished or not. I think they were really painted for himself or to give to friends. Were they for sale? Does it matter? Somehow the partly painted works have a charm of their own which is not always shared with some of the completely painted 'finished' pictures.

In *Man with Pushchair* (opposite) I was interrupted during the painting by a shower of rain. When I came back to finish it off I did not really know what to do and where to go! I looked at it for a long time and then it was cast off onto the scrap pile. I did not cast it off because I had spoilt it; I cast it off because I felt that anything else I did would detract from the part I had done. This is clearly an unfinished watercolour. Unlike *Sunlight Through White Petals* and *Tomatoes*, where I chose to finish the paintings, this one has stopped at a certain point, but not by choice. Does it really matter? All the information is there in the drawing and most of the important areas have been painted.

In fact, the longer I look at it the less inclined I feel to add to it. It is a watercolour with the spontaneity of being painted on site. The linking of the painted area originated from the requirement of the watercolour areas to bleed together (see my answer to the problem of 'lost and found' edges on page 88). Would I have to do more work if I wanted to exhibit it? No; I would be happy to exhibit it as it is. Perhaps, though, I would have to compromise and add a bit more if I wanted to sell it! But that is a different issue.

Sheep under Tree

35.5 × 37 cm (14 × 14½ in)

Thankfully the sheep stayed still long enough! I was enjoying developing a new way of approaching the painting of trees and decided to complete the painting while leaving some of the paper white. One is often tempted to fill in unpainted areas. It is important to design the unpainted areas within the composition.

UNPAINTED PAPER

Clematis on the Fence on page 123 is left partly drawn and partly painted. I painted it in my friend's garden and I enjoyed the challenge of representing the subject in this manner; that is, with the drawing being a vital part of the picture. In this watercolour I chose to finish the painting where I did. Is my watercolour regarded as unfinished simply because some of the paper is left white?

In *Sheep under Tree* there is no drawing left deliberately unpainted, but there are parts of the watercolour paper left untouched. The area where the painting clips the frame is quite an important aspect of the overall composition.

Unpainted paper may be left around a subject; sometimes one sees, for example, a flower painting where there is a border of unpainted paper. Alternatively, there are paintings where there is white paper but the main image clips the mount. I do not think it is the amount of unpainted paper that is left that might make the watercolour look unfinished. It is more a matter of how the painted area is composed within the picture frame. It is always important that the white space is designed with as much care as the painted areas.

OVERFINISHED PAINTINGS

Deciding whether a painting has been overfinished is the most difficult area. It is all in the eye of the beholder. In my experience, if too much information is put into a picture it can easily look overworked and fussy. Many people, though, love to include all the detail and feel it gives plenty of information. This is just a question of taste.

I have often said to my students if they were painting a daisy, for example, that two defined petals would be sufficient if the other petals were just implied. In my view each petal that is added simply detracts from the first two. But this is just an opinion and many people feel that each well-painted petal enhances the picture. The situation becomes important when students intend to paint just two petals and imply the rest, but cannot prevent themselves putting them all in! In *Hereford* (opposite) I felt I had spoilt the painting by adding

too much information. It is the area on the left with the weeping willow that worries me. I just filled in the space without really thinking, which reulted in a much heavier look to the painting. Before I added the final trees in this area the picture had a light quality to it. I was really cross with myself for overfinishing it, although perhaps most people would consider this painting to be unfinished anyway, because of the loose style.

REASSESSMENT

You cannot paint to please other people. When you finish a watercolour is your own choice. If you are concerned with overworking then you have to take a risk and train yourself to stop and reassess the work at an earlier stage. Put it to one side and look at it again another time and then ask yourself honestly whether any further work would improve it or not. I think by doing this we learn to look at the picture as a whole rather than at the particular part we are painting.

Another way to stop overworking a picture is to stop oneself filling in spaces. If you find an unpainted area, you probably feel you must put

Hereford
35.5 × 50.5 cm (14 × 20 in)

This is an example of a painting where I felt the picture had been spoilt by overworking. It is quite a loose painting and not overworked because there is too much detail, nor is the work muddied by too many washes etc. When I stopped painting I was disappointed in the area on the left; I had filled in the space with the weeping willow without thinking. Before I added those final trees the watercolour had a lightness and mystery and a desired open feel about it. Really, I just overfinished it!

something in it. As you add something are you taking away from something else? This is a question I ask myself constantly as I am painting.

Picasso, too, deplored the idea of the 'finished' work. He expressed it like this:

'To finish a work?
To finish a picture?
What nonsense!
To finish it means to be through with it, to kill it, to rid it of its soul, to give it its final "coup de grace" for the painter as well as for the picture.'

ARTISTS' BIOGRAPHIES

Ray Balkwill studied at Exeter College of Art. He worked in advertising as an art director, but increasing demand for his paintings led him to give up his job to become a professional artist. He has held numerous solo exhibitions and has shown in a number of group exhibitions, including the Royal Institute of Painters in Watercolour, the Royal West of England Academy and the South West Academy of Fine and Applied Arts. His work can be found in galleries throughout the West Country and he is also a member of the St Ives Society of Artists. Living on the coast, it is little wonder that the sea and its wealth of maritime subjects are his main source of inspiration, and he is a strong advocate of painting en plein air. Ray writes regularly for *The Artist* magazine and his work features in many other magazines and books.

Julie Collins was born and educated in the Isle of Man. She studied Art at Reading University in the early 1980s where she specialized in Painting. Since graduating Julie has exhibited widely throughout the UK and Europe, and has many years' experience teaching all aspects of painting and drawing. Well known for her large, free watercolours of flowers, exhibited at the Royal Institute of Painters in Watercolour, London, Julie has found increased freedom in her recent abstract work.

Sally Fisher studied Fine Art at Amersham Art School in the 1970s. She has taught classes in watercolour, still life, and anatomy, life and movement at The Working Men's College for men and women in Camden, London, and now teaches privately, including a life class, in Primrose Hill, London. She also teaches classes in watercolour nudes and charcoal nudes at Marlborough College Summer School. For the last 20 years Sally has worked as a freelance artist, illustrator and cartoonist. She produces monthly anatomical illustrations for *Health & Fitness* magazine and her daily cartoon 'Astrocat' appears in the *Mirror* on Jonathan Cainer's horoscope page. Sally exhibits in London and Winchester regularly, including the Mall Galleries, and the 'Not the Royal Academy' summer show at the Llewelyn Alexander Gallery.

Gerald Green has worked as a professional artist from his studio in the Midlands since the mid 1980s, having previously practised as an architect. His reputation as one of Britain's leading architectural illustrators is well known and his clients have included large national and international property development companies. He has been a finalist in many of the major national art exhibitions and his watercolour and oil paintings are currently available at several galleries throughout England. He is a regular contributor to *The Artist* magazine and his work has featured in five other books.

Barry Herniman MCSD had his first solo exhibition of watercolours in Ross-on-Wye in 1991 and gave up his graphic design business in 1997 to take up painting full time. He has exhibited in England, Ireland, Canada and the USA, and was the winner of the SAA Artist of the Year Award 2001. Although favouring watercolour, Barry also enjoys working in pastels, acrylic and mixed media (pastel and watercolour). He is a regular feature writer for *The Artist* magazine and has produced two instructional videos. He also runs painting holidays and short painting breaks throughout the UK and overseas.

Hilary Jackson NDD, ATD studied Painting at Bromley College of Art and Reading University. She has exhibited in London at Royal Academy Summer Exhibitions, the New English Art Club, the Royal Institute of Oil Painters, the Royal Society of British Artists and the United Artists, as well as at the Salon des Nations in Paris, and in the USA. Her work is in collections in the UK, USA and Japan. Following a career teaching art in secondary schools, Further

Education and Adult Education, Hilary now paints, tutors students of the Open College of the Arts, and writes articles and reviews for *The Artist* magazine.

John Lidzey taught graphic and typographic design at Camberwell School of Art during the 1970s and early 1980s. Following this, he turned to painting in watercolour on a professional basis. In 1990 he was awarded the Daler-Rowney prize at the Royal Watercolour Society Exhibition and two years later he was a prizewinner in the Singer Friedlander/*Sunday Times* Watercolour Competition. His work is known for its strong tonal values and the looseness of its brushwork. He regularly exhibits his work in East Anglia, the Cotswolds and London, and many of his watercolours are in collections in the UK, the USA, Europe and Australia. John is a regular contributor to *The Artist* magazine. He has written several popular books on watercolour painting and produced two instructional videos on the subject.

John Mitchell RSW, who trained at Edinburgh College of Art, is a member of the Royal Scottish Society of Painters in Watercolours and a professional member of the Society of Scottish Artists. He has shown watercolours and oils in one-man and group exhibitions throughout Scotland. Mountain landscapes and seascapes provide inspiration for many of his paintings. A regular contributor to *The Artist* magazine, he lives in Fife. His website address is www.largoart.co.uk

Anuk Naumann studied Architecture at University College, London, and qualified as an architect in 1975. Since meeting her husband, Roger, she has travelled to Africa and the USA, and while living and working in New York she studied silk-screen printing. Anuk paints a variety of subjects, with still life as her favourite. She works in water-based paints and increasingly uses collage in mixed media pieces. She holds exhibitions from home, but has also exhibited widely in England and Scotland. Various greetings card companies have produced her designs and her paintings have been published as fine art prints. Anuk has also produced two cat calendars. Examples of her work and explanations of her unusual technique can be found in several articles written for *The Artist* magazine and other publications.

Paul Riley began his artistic career at the age of 15 when, in 1960, the Royal Academy accepted one of his paintings for their Summer Exhibition. At that time he was the youngest painter to be exhibited by the Academy. After Art School in Kingston-upon-Thames, he left London to paint the bleak mining landscape around Merthyr Tydfil in Wales. Various solo exhibitions ensued before Paul returned to London, where he spent several years working in architecture. In 1980 he founded Coombe Farm Studios in rural south Devon, where he has since established himself as one of Britain's leading watercolourists. His work is exhibited both nationally and internationally with exhibitions in Europe and as far afield as Australia and Kuwait. He has written three instructional books on watercolour painting and regular articles for leading art journals, as well as teaching workshops throughout the year. He presented the BBC2 series 'Monet's Gardens'.

Tom Robb NND, ARCA, MCSD, FSAE, FRSA studied at Carlisle College of Art and the Royal College of Art. He has been a practising teacher of art throughout his career and was Professor of Fine Art and Head of School at Middlesex University until his retirement. His work has been shown in solo and group exhibitions in various well-known galleries in London. His paintings are held in public collections throughout England and in private collections in Europe, Canada, Australia and the USA, including the Mellon Collection in Virginia. Tom is the author of a number of practical art books translated into several languages and is a regular contributor to *The Artist* magazine and other publications.

Judi Whitton lives in the Cotswolds and is a well-established full-time watercolour artist specializing in flowers and landscapes. She has held many successful one-man exhibitions and is sought after for her teaching courses, workshops and demonstrations to Art Societies. Passionate about watercolour painting, she is very much an en plein air painter. She is constantly letting her 'style' evolve, while always endeavouring to preserve a sense of spontaneity in the finished work. Judi's watercolours have been featured in the *Radio Times* as well as other publications and she is a regular contributor to *The Artist* magazine.

INDEX